EMILY CARR
in England

Kathryn Bridge

ROYAL BC MUSEUM

Victoria, Canada

Published by the Royal BC Museum,
675 Belleville Street, Victoria, British Columbia,
V8W 9W2, Canada.

Edited by Gerry Truscott, with assistance from Amy Reiswig.
Designed by Jenny McCleery.
Typeset in Minion Pro 11/13.
Digital production by Shane Lighter and Kelly-Ann Turkington, with
curatorial assistance from Don Bourdon.

Printed in Canada by Friesens.

Library and Archives Canada Cataloguing in Publication

Bridge, Kathryn, 1955–, author
 Emily Carr in England / Kathryn Bridge.

This book contains three of Emily Carr's "funny books" created
 while in England: A London student sojourn, The Olsson student,
 Kendal & I.
Includes bibliographical references and index.
ISBN 978-0-7726-6770-0 (bound)

 1. Carr, Emily, 1871–1945. 2. Painters – Canada – Biography.
3. Painters – England – Biography. 4. Canadians – England – Biography.
I. Royal BC Museum, issuing body II. Title.

ND249.C3B75 2014 759.11 C2014-905921-3

Contents

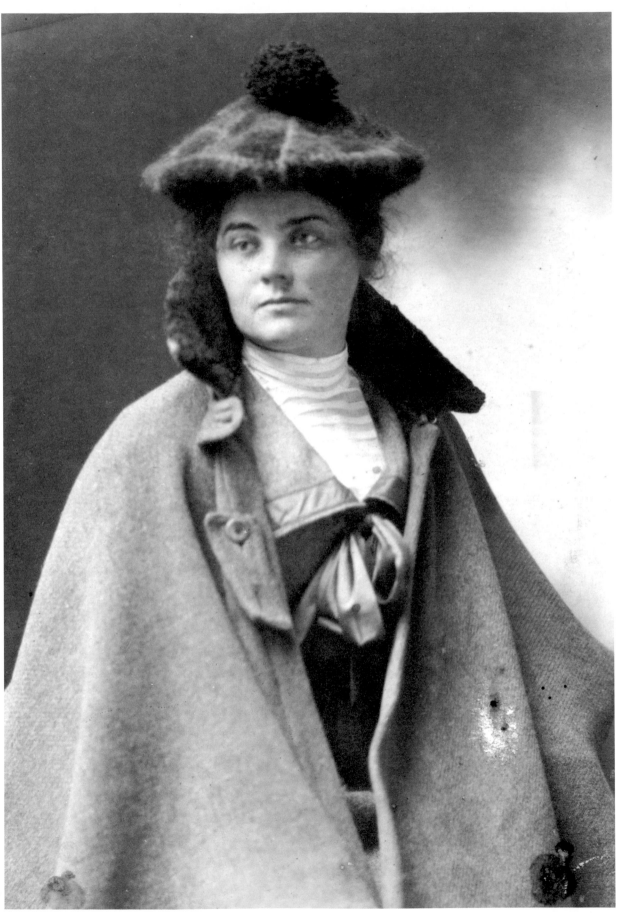

4

Preface

Emily Carr in England has three purposes. First, it is part of an ongoing initiative to bring forward to the wider public the rich and important archive of Emily Carr held by the Royal BC Museum. It follows two earlier publications that featured previously unpublished stories, one about wildflowers and the other of her 1910 trip across Canada en route to France. *Emily Carr in England* features sketches and cartoons from the RBCM holdings that humorously record her life in a London boarding house and activities in English art schools. It also includes an early manuscript that holds important details of life in the art schools at St Ives and Bushey. That Carr titled it "Growing Pains" makes it confusing, as it is the same title of one of her published books, but the content is quite different and it has rarely been utilized by researchers until now. Second, it contains previously unpublished material: quotations from letters written by Carr while in England, and letters received from English friends – again, rarely utilized – and a recently located "funny book", in which Carr depicts herself and a friend trying in vain to witness the funeral cortège of Queen Victoria in 1901, and a newly acquired verse and watercolour story from her English adventures. Third, it attempts a new chronological ordering of Carr's almost five-year stay in England, based upon extensive new research, and revealing many of the actual personal names of friends mentioned only with fictitious names in Carr's published *Growing Pains*.[1] This adds to our understanding of her relationships, as many of the people in her world – both in Canada and England – were bound by what in contemporary terminology is described as only a few degrees of separation.

This book is not intended to be a comprehensive recitation of all the episodes featured in *Growing Pains* – readers should enjoy Carr's own telling first hand. Nor does it adequately analyse the art scene or personalities in the art worlds that Carr travelled in and intersected with during her time in England. That is worthy of another publication. But what it does do is fill in many gaps, provide historical context for some of her own commentary in *Growing Pains*, and begins the process of reworking a more intensive and accurate

1 *Growing Pains, The Autobiography of Emily Carr* was first published in 1946, a year after Carr's death. The citations in this book are taken from the 2005 edition.

Emily Carr at St Ives, December 1901.
John Douglas photograph; I-60891.

chronology of the years 1899–1904. The research benefitted from the digitized 1901 census for England and Scotland to trace surnames and locate residents by street address or village, and from many other online resources for genealogical or historical events. Ongoing digitization of censuses, directories and many other archival sources make cross referencing and fact checking much easier (and even possible) than in the pre-computer search days of Carr's foundational biographers.

Acknowledgements:

Thank you to the following:
Linette Frewin and Jody Frewin, David Tovey, William F. Locke-Paddon, Marion L. Carter, Stephen Bartley, Lisa Baldissera, Dr Patrick Forsyth and the Bushey Museum, St Ives Museum, Westminster Archives, Vancouver Art Gallery, McMichael Canadian Collection, City of Victoria Archives.

Introduction

The art and writings of Emily Carr continue to inspire. Oil on canvas, watercolour on paper, charcoal and pencil sketches are fixtures of international auction sales. She is front and centre in our creative consciousness. Emily Carr is Canada. She is a cultural ambassador, speaking to global audiences through her paintings, revealing the landscape and peoples of British Columbia, her home province. She understood the forest, regeneration of the land, growth and movement in nature. She observed and interpreted. She captured her world in great subtlety and wild abandon. She drew upon her life experiences, on her training and personal interactions with fellow artists for insight.

Generations of readers also learned of Carr's life through her own words in autobiographies she wrote in her later years, when the sheer physicality of painting eluded her, when heart troubles and an aging body required more sedentary pursuits. *Klee Wyck* (1941), *The Book of Small* (1942), *The House of All Sorts* (1944) and *Growing Pains, The Autobiography of Emily Carr* (1946) together cover her adventures and discoveries in the coastal villages of First Nations; her childhood and youth; her art training and practice; her times in England and France; and her life as an artist, teacher and landlady. Later collections of previously unpublished stories in *Heart of a Peacock* (1952), *This and That* (2009) and *Wildflowers* (2009) continued to reveal only part of the inner Carr.

It is only *Hundreds and Thousands* (1962), an abridged selection of Carr's own private journal entries from the mid 1920s to the early 1940s, and the careful reconstruction of excised journal entries in Susan Crean's *Opposite Contraries*[2] that enable us to read her innermost thoughts without the mediation of time or her own retrospective interpretation. So also do the extant letters written over her lifetime to friends, fellow artists and family. Carr's private cartoon-and-verse "funny books", as she called them – such as *Pause* (1952), *Sister & I From Victoria To London* (2011) and the *Alaska Journal* (2013) – each reveal her comic recording of specific episodes in her life. She created the illustrations for *Pause* in 1904 after her release from the East Anglian Sanatorium in England, and decades later added the prose. She wrote

2 Crean 2003.

and illustrated the latter two in 1910 and 1907, respectively, recording travels with her sister Alice.

But the story of Emily Carr as she presented it in her own published books and stories was a carefully crafted one, relying on selective recollection with deliberate intent. She wrote in old age, looking back with hindsight and often some nostalgia, but also at times with bitterness at slights never forgotten. Digging deep into memory she relived her past through the lens of her own life's many layers and successfully conveyed clear emotions that loomed fresh to colour her words. She was clever – her stories charm and provide much delight. She served up many of her childhood memories as bite-sized snapshots filled with colourful characters – some endearing, some comic, others pathetic. We learn of early friendships, of neighbours, of her family. The foibles of relationships appear honest and insightful. We are introduced to her art teachers, to her American, English, British Columbian and eastern Canadian adventures, to people who helped and those who hindered her. And we delight in her pared down yet bang-on-the-money word pictures, the often absurd adjectives, the creative misspellings. It is all part of why we love her and why Carr continues to speak to us, 70 years after her death. As art critic Robin Laurence wrote, "emotional truth and dramatic impact usually prevail over mere fact.... That's why *Growing Pains* makes for such good reading."[3]

But for historians working to put her life in context of the times, to discuss Carr the artist in relation to art movements and other artists, to set Carr into the history of Victoria, Vancouver and British Columbia, and the other places she lived and learned in – San Francisco, England and France – the trail is difficult to follow. Although she wrote about people and places, basing the stories on her own experiences, the stories "are not accurate accounts of her past ... they are a mere reflection, altered and coloured by literary instinct."[4] Carr conflates situations, compresses time, rearranges dates, lies about her age and, most frustratingly, fictionalizes the names of almost everyone she mentions, with the exception of close family and some intimate childhood neighbours. One literary scholar observes, "the two apparently contradictory impulses, revelation and self-protection, appear in a wide variety of guises in all of her prose."[5] Carr wanted us to only know a filtered version of her life.

Thus, when it came time to examine closely her years in England as this book does, the chapters she devotes to England in *Growing Pains* (roughly half of the book) that provided her previous biographers the structure on which to cover the important years of 1899 through 1904, are found to be woefully lacking in clear substantiated detail. Of all the periods in her life, these years in England have remained the least researched. Carr's first biographers, Edythe Hembroff-Schleicher, Maria Tippett and Paula Blanchard[6], each created narratives

3 Robin Laurence, "The Making of an Artist", introduction to *Growing Pains* (Carr 2005).
4 Tippett 1979, p. 249, quoted in Thomas 1993.
5 Elderkin 1992. See also essays by Johanne Lamoureaux and Marcia Crosby in Thom et al. 2006.
6 Tippett 1979, Hembroff-Schleicher 1978 and Blanchard 1987.

by threading together Carr's own published accounts, which for this period in her life were already lean. In books of 200 pages or more, these biographers each devoted less than 10 pages to her four and a half years in England – a time in her life when she transformed into a serious artist intending to make her life's calling as a professional and when her personal life unravelled so significantly. These years changed her forever. She grew into a mature woman, and her growing pains were both artistic and psychological. It is thus a pivotal time and overdue for scholarly examination.

None of these biographers seriously challenged the chronological sequence Carr presented in *Growing Pains.* Carr's own stories were considered essentially factual, and when they left gaps, or omitted sufficient detail to enable reconstruction, the biographers speculated. With the passage of time, these speculations became accepted as historical fact, entrenching and, in some cases, affirming interpretive errors or guesses. This situation is no one's fault save Carr herself. Did she deliberately obfuscate? Certainly she changed people's names to protect those still living from identification and potential embarrassment. She had learned from past mistakes, after discovering that some of the comments she made in *The Book of Small* hurt her sister Alice. So, she intended *Growing Pains* to be released posthumously. In a letter to her great friend and literary advisor Ira Dilworth, she said: "I would not want her published 'til *"Emily" is dead.* One would feel foolish and it would hamper one from

writing so freely."[7] This suggests that Carr the author knew that in her quest for the best story, she had to be creative. A little from here, a little from there, a blending of memories and mixing of detail enabled her to intentionally build chapters, to get her points across and reinforce themes. Emily knew that if she published *Growing Pains* in her lifetime she would be subject to criticism by those who featured in her stories, either because she painted them in a harsh light or because she creatively changed the situations.

The stories in *Growing Pains* can be divided into two types – those now found to be based upon blended historical episodes, and those with very little setting but largely dependent upon Carr's observation of personal character and her emotional response. It seems clear that her first priority in *Growing Pains* was to entertain her readers. She held back many private details. This would explain stories that are thin on historical context and instead emphasize human dramas. In 1942, while writing the chapters for *Growing Pains*, she told Dilworth: "I so reduced the parts that would make me squirm and feel silly I don't guess I'd mind. What do you think about it? I don't think I've left myself too naked. I couldn't bear the whole public and I'd hate the ridicule of *my own relatives.*"[8]

Feminist analysis of Carr's life writing interprets it as "deliberately self fashioning…. She is careful to reveal only those parts she wishes the public gaze to fall upon and never allows her readers to

7 Emily Carr to Ira Dilworth, 28 December 1941. Transcribed in Morra 2006, p. 82.
8 Emily Carr to Ira Dilworth, 15 February 1942, quoted in Crean 2003, p. 228.

Emily's Old Barn Studio
Emily Carr, ink on paper, 1891; PDP9005.

do more than [see] dimly inside."[9] As the product of her "latter years, most of that writing is characterized by qualities of reflection and stasis".[10] Seen in this light then, *Growing Pains* and her other books take the form of a series of anecdotes purposefully not organized in strict chronology, nor are they tightly thematic or contiguous, which would give unity and enable the reader to have a sense of progression. Instead, they flit between first- and third-person perspectives, between satisfyingly complete and fragmentary morsels. They are disjointed, perhaps intentionally so, as Carr emphasized multiple and fluid simultaneously held subjectivities, not willing to present herself as a single – perhaps limited – identity.

9 Elderkin 1992.
10 Walker 1996, p. 83.

She was guarding her innermost self but anxious to leave a record of her multiple selves over time, emphasizing her emotions, explaining how she experienced situations in her life.

Growing Pains also presents large themes that Carr reinforces and overtly threads through her narratives. She trumpets the proudly Canadian girl who arrives in London and is met with rude or indifferent Londoners who belittle her colonial roots. She also emphasizes her overwhelming physical reactions when separated from the natural landscape. She acts out, plays the fool, adopts mannerisms to hide her insecurities and through these means connects with her peers by being deliberately provocative. Carr emphasizes her struggles to be recognized as an artist and her aloneness in these struggles. Over the years these themes have become the shorthand for interpreting Carr and, sadly, she has become a little flat in the telling. We have forgotten, or never known, that Carr's life was more complex, richer and full of options. She was loved, treasured and, if not completely understood by those close to her, important to them in her own lifetime.

Reconstructing Carr's years in England is also complicated by the dearth of extant visual documentation. There are only two photographs known, both taken at a single sitting in 1901. Given that it was the age of Kodak cameras, one would hope that eventually images might surface. But it is the lack of artwork that is most perplexing. Considering her intention was to practise her art and that her focus was

in art studies, in working under drawing masters and in creating art, remarkably little has survived that can be conclusively dated to this time. Reasons are many. She elected not to retain "student work"(for that matter, nothing exists from San Francisco), or she kept and later destroyed works, or she decided to only bring home a small selection of works created in England.

What has survived are four sketchbooks (two with only partial pages remaining), several cardboard-mounted cartoon-and-verse panels, and "funny books" that recount humorous events or situations Carr discovered herself in or that she observed in her everyday routine. A single oil painting of English trees exists, overpainted and obscured on the back of a canvas painting created decades later. This last is the only evidence of her finished work from England, probably from St Ives. Thus, we can only conjecture about the art she produced for her teachers, about the oil paintings and watercolours created *en plein air*. We cannot see what her art looked like, its style, technical proficiency, or how it compared to her fellow students, many of whose work is found in public collections world wide. It's no wonder that this five-year period in Carr's early life and career has been understudied.

Uncovering the details of Emily Carr's life (complicated as it is through lack of visual evidence) is a frustrating and endlessly convoluted process, as nothing she writes can be taken as completely truthful or historically accurate. But the act of searching is addictive – small glimpses emerge, inconsistencies provoke new questions. These findings enable researchers to correct past misunderstandings and, in so doing, gain new insight into some of the parts of Carr that she shut away from the public. By undertaking new historical research and deconstructing her published writings, reading thoroughly her unpublished "Growing Pains" and contemporary letters, then by pulling apart the chance references and triangulating sources, examining closely the extant sketches and watercolours for subject matter and reading the doggerel verse that accompanies the images in her funny books, it is possible to find, stored away below the surface, new storylines and themes. We gain a fresh understanding about not only Carr's daily living but her depth of character and her hobbies, interests and passions – all contributing to understanding her as a more well-rounded, real person. We find a Carr who treasured her friends and kept touch with many of them, including her teachers, years after visiting England. We find emerging a new picture of Emily Carr.

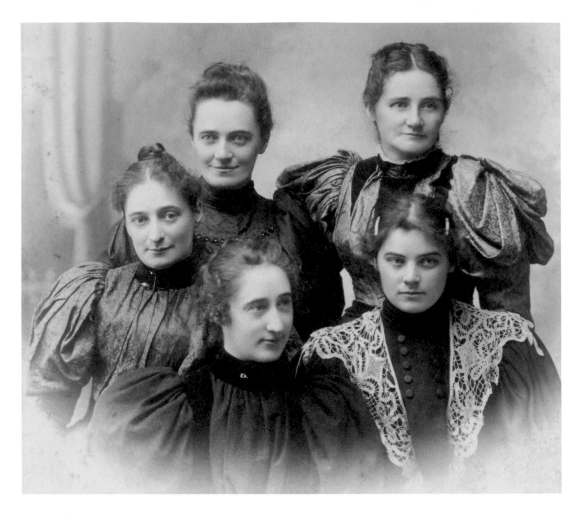

The Carr sisters, 1895–99, clockwise from top right: Clara, Emily, Alice, Lizzie, Edith.
Hall and Lowe photograph; A-02037.

1899–1900

1899 was a pivotal year for Emily Carr. It started out rather tame and ordinary: art classes for children based in the cow barn behind the family home at 44 Carr Street (now 207 Government Street) kept her in a basic weekly routine, as did sketching trips with students and friends to spots around the city.

It was now five years since her return from art studies in San Francisco. She continued, as she had for the past few years, to sing at the Church of Our Lord. Carr was also a member of a guitar and mandolin club. Newspaper accounts document Emily participating in charity concerts as a musician, singer and, on more than one occasion, a soprano soloist.

Emily played lawn tennis on the family's court made on the site of her father's vegetable garden. We know that lawn tennis was a popular activity for the Carr sisters and their friends who played in daily sequence on the courts of others such as the Crease and O'Reilly families, each of whom had carefully maintained grass courts.[11] Edith, Elizabeth, Alice and Emily together lived in the family home, while sister Clara, who in 1882 married John

11 Bridge 2012, pp. 240–41.

THE following is the programme of vocal and instrumental concert which is to be given this evening at the Reformed Episcopal school room, commencing at 8 o'clock:

Pianoforte duet—"Witches' Frolic" (Caprice)............................Behr
Mr. and Mrs. Bradley.
Song—"Day Dream"...........Strelezki
Miss Hartnagel.
Song—"Venetian Waters"....Otto Roeder
Mr. Lang.
Piano solo—"Spring Song"..Mendelssohn
Miss McGregor.
Song—"Serenata" (with cello obligato)
..Brago
Mrs. Laundy.
Song—"Bedouin Love Song".....Pinsuti
Mr. Booth.
Song—"Slumber Song"...................
Miss Eva Bradley.
Piano solo—"Morceau de Salon".......
.................................L. Bradley
Mr. L. Bradley.
Song—"Still as the Night".........Bohm
Miss Millie Carr.
Vocal duet—"In Meadows Green"....
..............................Brackett
Mr. Laundy and Mr. Bradley.

AT the Reformed Episcopal church this morning the choir will sing Dr. Sullivan's anthem, "O Taste and See." At the evening service Dr. Whitfield's service will be given and a sacred solo, "The Palms," will be sung by Miss Millie Carr.

"Millie" Carr's participation in public performances is documented in the *British Colonist* newspaper from 1895 to 1897. These two notices appeared on February 9 and March 4, 1896.

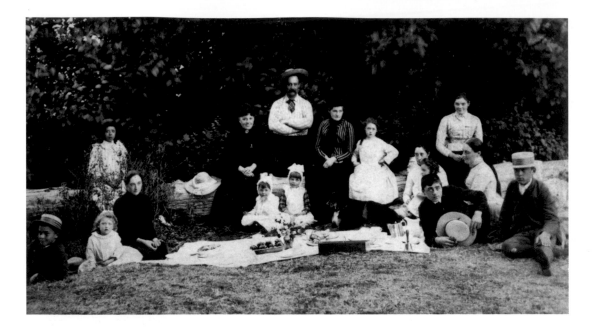

The Carr family and friends on the beach at Gonzales Bay, Victoria, about 1887. Richard (Dick) is reclined on the right with hat in hands. Edith and Alice sit behind him and Emily behind them on the log; Lizzie kneels on the ground with the children on the left; and Clara, in a striped blouse, sits in the centre on the log beside her husband, John Nicholles. The woman on the log next to the Nicholles is thought to be Emily's friend, Nellie Laundy. The young man on the far right is an unknown friend. The children belong to the Nicholles and Laundy families, and possibly the neighbouring Alexander family.
Unknown photographer; Vancouver Art Gallery (digitized from a 1960s print).

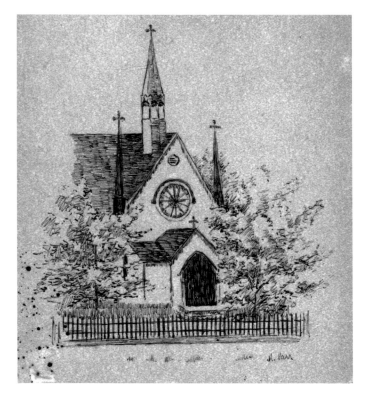

Nicholles, resided nearby, at 220 Dallas Road with their six children. Photos of the Carr sisters and friends at a local beach and alongside the gazebo in the Carr garden include Emily, showing that rather than being alone and separate, she participated, was part of outings and included in social events. We see evidence of an Emily who, although she may have considered herself as different in later life, was fully participatory, noted in the social scene of Victoria's settler elite.

Emily shared responsibility with her sisters for the upkeep and running of the family home, but it was Edith, as the eldest unmarried daughter, who held the purse

The Church of Our Lord
Emily Carr, ink on paper, about 1896; PDP9889.

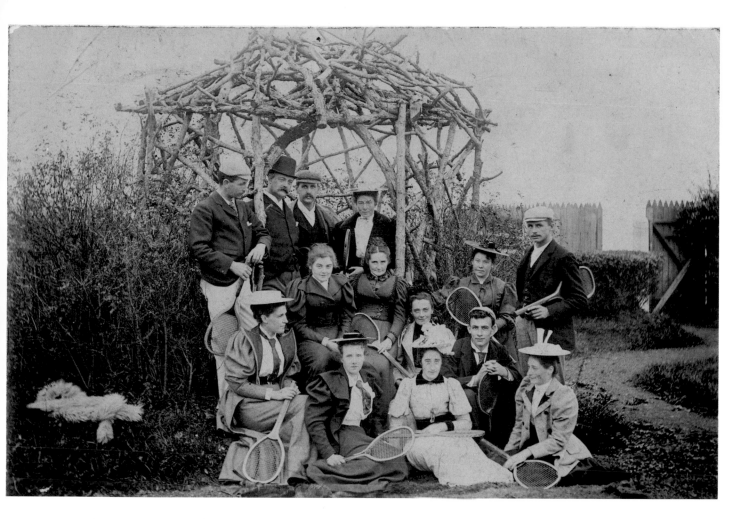

Lawn tennis party at the Carrs' property, possibly 1899. Emily and Clara sit in the centre; Edith kneels on the ground beside Clara, Alice sits in front of Edith and Lizzie sits on far right. The others may include Emily's friends Edna Green and her siblings, Maude Cridge, and possibly other Cridge family members. Mayo Paddon may be the man on the left looking at Emily.
Hall and Lowe photograph; I-61507.

strings. The Carr parents died years earlier, the mother in 1886 and the father in 1888. As befitted gendered practice of the day, Richard Carr's will appointed James Hill Lawson, a respectable male, as trustee. Lawson, a neighbour and family friend, managed the estate and its investments and provided Edith with a monthly allowance to cover the sisters' expenses. Younger brother Richard (born 1875), who suffered from tuberculosis, was not at home in 1899 but in California where the warm, dry weather was considered better for his lungs. Dick, as he was known, had earlier attended boarding schools in Washington and later at Ridley College, Ontario, from where he was withdrawn in 1892, presumably for health reasons.[12] In early 1893 while

12 Richard Carr to Emily Carr 14 May 1890, MS-2181, BC Archives. Tippett 1979, p. 284, references private correspondence with Ridley College. My email with the college provides no further information; records indicate only generally that Dick withdrew in 1892.

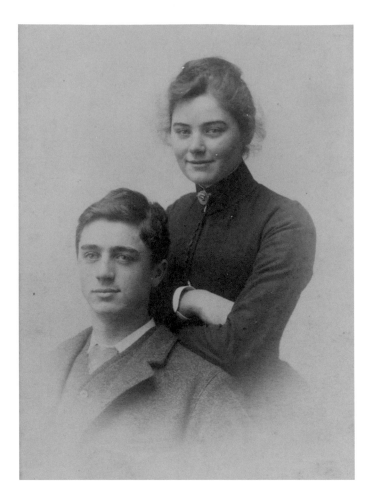

Emily Carr and her brother, Richard, about 1890.
Hall and Lowe photograph; I-60892.

Emily was in San Francisco at art school, Dick arrived in Santa Barbara. After Emily returned to Victoria in the spring of 1894, Dick made at least two more visits home, in December 1894 and July 1895. The sisters took turns visiting him and exchanged letters.[13]

In 1899 Emily socialized with neighbours and childhood friends such as Nellie Cridge, who lived at Marifield, situated across Carr Street and a few lots north from Carr's house; and Edna Green, whose large family had lived closer to James Bay on Birdcage Walk but had recently moved to Moss Street, several kilometres distant. Over the years Carr had sketched with Theresa Victoria Wylde (1870–1949) and Sophia (Sophie) Theresa Pemberton (1869–1959), two other Victoria girls her age with artistic aspirations. Both now studied in England, yet they returned to Victoria each year. In 1897 Wylde, registered at the Kensington School of Art, made her public debut with a painting hung at the Royal Academy. By February 1899 Wylde had returned to London. Pemberton was also home from London on hiatus, having already successfully exhibited, like Wylde, in 1897 at the Royal Academy. In March 1899 Pemberton received news that she won the Prix Julian for portraiture.[14] There was a certain pressure, perhaps, for Emily to match the achievements of her contemporaries; at the very least, these young women were examples to follow. Carr would turn 28 in December 1899. It was five years since her return from San Francisco art school and her indoctrination into a life beyond the confines of her hometown. She was due for

13 In later years when referencing Dick, Carr minimized her interactions with him. Contrary to a comment made in a letter to Dilworth on November 22, 1942, ship passenger lists show Dick visiting Victoria and various visits by the sisters south. He arrived in Victoria June 1893, then went back to California that October. He returned again to Victoria in December 1894 and again in July 1895. Ship passenger lists show various Carr sisters to and from San Francisco. www.britishcolonist.ca.

14 "Miss T. Wylde left this morning for London," *British Colonist*, 25 February 1899, p. 3. Sophie Pemberton was named in this newspaper for her participation in tennis tournaments and other social events in Victoria until late July 1899. See also Tuele 1980.

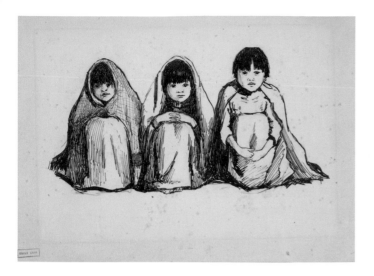

Three Girls, Ucluelet
Emily Carr, ink on paper, 1899; PDP00626.

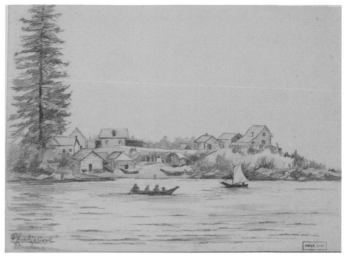

Dan's House, Etedsu [Ucluelet]
Emily Carr, ink on paper, 1899; PDP00640.

a shake up, time to move forward with her dreams.

And so she schemed. Her "old pair of hoarding shoes" hung in the rafters of the cow barn studio where she taught children's art classes. After a time they "were crammed with money."[15] She almost had enough savings to follow the examples of Wylde and Pemberton, to make her passage to England, and pay for art lessons in London and expenses – as long as her sister Edith, who held the family purse strings,

would agree to send monthly cheques, her own fair share of the income left to the sisters upon her father's death those many years ago.

Emily's spring season was filled. Her sisters Edith and Lizzie (or Betty Ann, as the sisters more regularly called her) were women whose souls were filled with the need to perform "good works". They organized a number of charity fundraisers held in their gardens; Edith was president of Victoria's fledgling Young Women's Christian Association; and Lizzie was particularly interested in the work of her missionary friends, some of whom administered to First Nations on the west coast of Vancouver Island. Emily was invited to visit the Presbyterian Mission school at Ucluelet by one of these friends, E. May Armstrong. On April 2 she travelled north on a coastal steamer, the *Willapa*, that put in at several communities, delivering mail and supplies.[16]

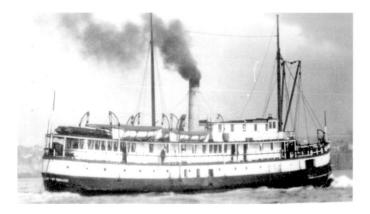

The S.S. *Willipa* on the West Coast, 1890s.
Unknown photographer; B-04327.

15 Carr 2005, p. 111.
16 The *British Colonist* lists the *Willapa's* departure from Victoria on April 2, 1899, and its return on April 19, with Carr as a passenger.

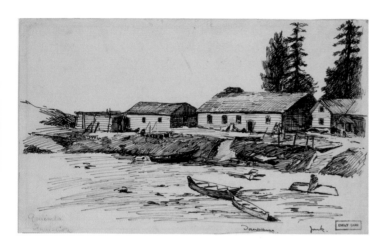

Phish's Cove, Etedsu [Ucluelet]
Emily Carr, graphite on paper, 1899; PDP00627.

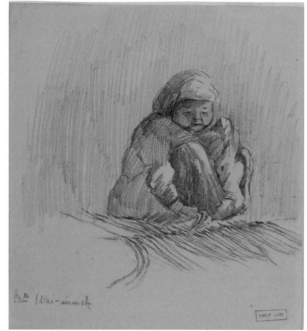

Mrs Wai-in-uck, the old mat maker
Emily Carr, graphite on paper, 1899; PDP0593.

The fortnight Carr spent at the mission in the First Nations community of Hitachu, across the bay from Ucluelet was her first experience of living among First Nations. She brought sketching paper and made drawings of people and their houses, the beach and village settings. This opportunity would be a dormant seed, a treasured series of remembrances, and the beginnings of her identification with a Canada that was broader than her hometown of Victoria, was different than the Americanness of San Francisco. According to her own accounts, Carr also came back with a new name, Klee-Wyck ("Laughing One") bestowed upon her by an old First Nations woman she calls Mrs Wai-in-uck. Klee-Wyck was a name she would treasure and one that would come to hold extraordinary meaning for her, as it defined and enabled her to establish the context for her public self and to create an aspect of her own private self image.

On the *Willapa* Carr met and conversed with the ship's purser, William Locke "Mayo" Paddon, a Victoria resident whose family lived near her friend Edna Green. It is possible that they may already have known each other, but a spark was lit between them and soon Paddon began to visit Carr to court her. But Mayo was not the only person of romantic interest for Emily this year. We know that the spring of 1899 was a time of conflicted yearnings of the heart. "Immediately upon my return from the West Coast Mission, I tasted two experiences for the first time – love and poetry…. I gave my love where it was not wanted; almost simultaneously an immense love was offered to me which I could neither accept nor return. Between hurting and being hurt life went crooked."[17]

17 Carr 2005, p. 111.

The first reference in this quote has always been a matter of speculation, tantalizingly and fleetingly mentioned in scraps of unpublished stories and letters. The latter is a reference to Mayo Paddon, whom Carr discusses at length in *Growing Pains* under the fictitious name Martyn. The reference to poetry may be connected with this first mystery man but documents what would be a life-long appreciation of poetry as inspiration and reflection. Carr began also to write poetry. Certainly an interest in verse inspired her to pen humorous accounts of her adventures and to enliven her solitary moments.

Connecting with Paddon scant months prior to her planned overseas journey was bad timing and perhaps, for Carr, an inconvenient complication. Nevertheless, she went forward with her intention. In mid July 1899 Carr booked a steamer to Vancouver, connected to the Canadian Pacific Railway and travelled across Canada to Montreal. There, she boarded the SS *Cambroman*. The passenger list shows 76 passengers. Carr travelled first class along with 10 others, paying $50 for her ticket. A further 23 passengers were second class, while 41 travelled steerage.[18] It was a direct voyage to Liverpool where she arrived on August 2.[19] She was terribly seasick on the ten-day voyage and dependent upon the kindness of other passengers and the crew, including a young doctor who later visited her in London. Landing in Liverpool in a weakened condition, Carr then had to get to London. In *Growing Pains* she relates that a fellow passenger, "Mrs Downey" (who apparently had the maiden name of Carr, but was no relative) took it upon herself to assist Emily on the train south to London and Euston Station. This is probably true, although according to the passenger lists, it was a Mrs Dowling.[20] Emily arrived in London by train and followed the protocols previously arranged – that Emily would be met by "Miss Amelia Green," the sister of an "old lady friend" with whom she would lodge. And meet they did. Miss Green "lived in West Kensington – one of those houses in a straight row all alike and smeared with smug gentility." She took in not boarders, as Carr mistakenly termed them, but "Paying Guests." There were six in total, and Carr disliked each one. "Their hard, smooth voices cut like ice skates."[21] In *Growing Pains* Carr states that it was "the make-believe gentility" of the paying guest house that hastened her move to new quarters,[22] but in a letter written several months after

18 The original record clearly lists a "Miss Carr", age 21. The transcribed online index created by Ancestry misinterpreted the original handwriting as "Miss Curr, age 4", presumably travelling alone. This transcription error may explain the difficulties in earlier determination of the exact voyage. Ancestry.co.uk original record in National Archives BT 26/141/20. discovery. nationalarchives.gov.uk/SearchUI/details?Uri=C2474058 and www.timetableimages.com/ maritime/images/dom99.htm.

19 Although Carr travelled by Canadian Pacific Steamship Company vessel to England a few years later in 1910 en route to France, she did not do so in 1899 (despite saying so in *Growing Pains*) because these vessels were only dispatched for Atlantic crossings in 1903.

20 Mrs E.M. Dowling (born 1857) is listed as a fellow first class passenger on the *Cambroman*.

21 Carr 2005, p. 118. If we assume Carr used the actual surname of Green, the 1901 England census lists Amelia Green at 14 St Mary Abbots Terrace, Kensington, a "Lodging House Keeper" with six boarders. She would have been 43 years old in 1899.

22 Carr 2005, p. 145.

that move, she confessed that Miss Green herself had been very kind to her.[23]

August and early September 1899 was a time of orientation, and Emily immersed herself in London. "I climbed the curving little iron stairways at the back of omnibuses and, seated above the people, rode and rode." The city perplexed her, its immensity overwhelmed but it was "the writhe of humanity" the crowds, the sheer numbers that was the biggest adjustment.[24] Her earlier experiences living in San Francisco paled in comparison. Residing in the midst of a hot, muggy and grit-filled London summer took some adjustments. "London stewed, incorporating the hot murk into her bricks all day and spitting it out at you all night."[25] Kew Gardens with its immense stands of trees, shrubs and floral specimens from around the world became her refuge. "I loved Kew,"[26] she later wrote. She breathed in the smells of cedar in the Canada plantings, sensory reminders of the West.

In September Carr registered at her chosen art school, the Westminster School of Art, housed in the Royal Architectural Museum at 18 Tufton Street, just doors from the great cathedral. There she met Francis Ford,[27] the museum's curator, who received her tuition and signed her up for two classes.[28] One was an all-day segregated ladies life class. This was a huge step for Carr, whose previous courses in drawing people had been restricted to clothed models. Drawing from life was the sign of a committed and serious student of art, one who had already undertaken still-life and other figure classes in preparation – experience, Carr argued to Ford that she had previously in San Francisco.[29] Although the classes started on time according to the term calendar, apparently the "professor" of the life class was absent for the first two weeks, so Carr had the opportunity to become familiar with drawing from the nude without the pressure of "crits" – when masters critiqued student work – right away.

Previous scholars identified the life class teachers as either William Mouat Loudan (1868–1925) or James Black, but this is unconfirmed. Annual reports for the time Carr attended are not fulsome, listing only J[oseph?] Holgate as headmaster, while Loudan seemed to have come on strong a few years later and became headmaster in 1904. Unfortunately, the names of instructors for the exact years she was at the school are not easily identified. Loudan may very well have taught Carr, as might James Black and Joseph Holgate, drawing masters associated with the school. Records of fellow students might assist, but no

23 Emily Carr to Nellie (Cridge) Laundy, 19 January 1900. PR76, City of Victoria Archives.

24 Carr 2005, p. 121.

25 Carr 2005, p. 118.

26 Carr 2005, p. 120.

27 Francis Ford appears in the 1901 census as a widower aged 70, with occupation listed as "Curator of Museum". His household included his niece and a domestic servant.

28 Tippett (1979) states three classes initially, "ladies' costume model class, the evening class of [commercial] drawing in black and white and the segregated ladies' life class." Hembroff-Schleicher (1978, p. 24) correctly states that only two are listed on the September 1899 receipt. MS-1077, BC Archives. In subsequent terms Carr undoubtedly added additional classes. She later referenced "night classes – design, anatomy and clay modelling." (Carr 2005, p. 191.)

29 Carr 2005, p. 141.

class lists survive. The evidence from Carr herself is not forthcoming; she did not write about the masters, and the only image she created of her classes is a cartoon in which it appears that Francis Ford might also have instructed.

In the cartoon (shown on page 22), Carr – depicted with her characteristic slash line eyes – is seated second from the right. In the centre is a serious discussion between Ford and a pupil. The image – useful for documenting the all-female cohort of the class (suggesting it was "ladies costume model") – is surrounded by Carr's poem explaining that the saucy student was unlike the remainder of the class who were "quiet and conforming mice" as seen in their downcast demeanour. The poem suggests conservatism, a practice that, at this time at least, Carr had not rebelled against. A faint pencil annotation on the bottom right provides the name of the saucy student as Blanche.

Exactly why Carr selected the Westminster School of Art is uncertain. Presumably its earlier reputation as cutting edge made its way out west to Carr's ears in Victoria, but by the time she arrived it had become more mainstream – offering competent, traditional studies – and was very popular as such. According to the school's annual reports, during Carr's tenure it boasted 450 pupils yearly, by any estimation a successful enrolment.[30]

These first months in England represented great transitions for Emily. Far from her home, away from everything familiar, she lodged in the nation's capital city. London – the metropolis – was the geographical, political and cultural heart of the British Empire, the centre from which radiated in all directions various overseas British possessions like Vancouver Island. Living in London, she said, was to live in "the kernel of England."[31] Carr's parents and many of Victoria's pioneering families considered England as *home*, for it was the place they had emigrated from. It was the place held tight in memory, described to offspring and held up as comparison to the new and different land of the West. Carr's two eldest sisters had lived in England and may have held early memories, but Emily viewed the land and the people through her own eyes and from the perspective of her own life experiences. In consequence, she saw a very different land from that of her parents' romantic remembrances. She saw a land cultivated in every corner, a city populated to the point of uncomfortable density and, within it all, a clearly defined class-based society in which she was essentially an outsider. Londoners viewed her as a colonist. Her accent when speaking, her choice of words and her viewpoints set her aside as "other" not as English. In California, her colonial accent had also set her aside, but differently. There, Americans interpreted her English tones as cultured. There, she was accorded privilege. But in England her accent betrayed her colonial status, thought by some to be less privileged. For the class-conscious English, and specifically for the upper middle

30 Loudan is listed as headmaster after the school moved location, from 1904 to 1918. Enrolment figures cited in: Information file, Westminster School of Art F706.2. City of Westminster Archives, London, UK.

31 Carr 2005, p. 123.

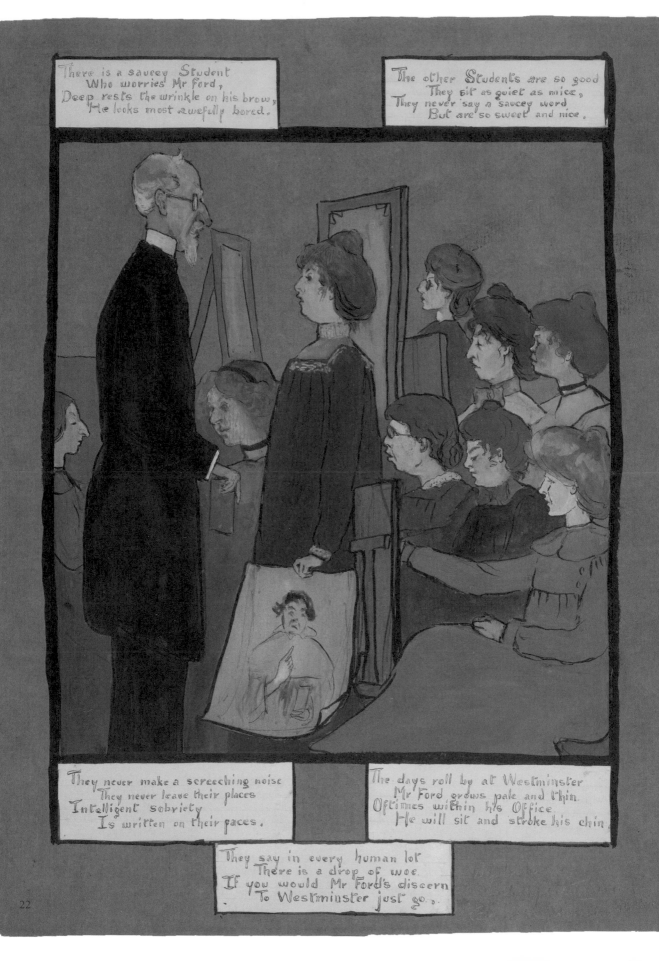

There is a saucey Student
Who worries Mr Ford,
Deep rests the wrinkle on his brow,
He looks most awefully bored.

The other Students are so good
They sit as quiet as mice,
They never say a saucey word
But are so sweet and nice.

They never make a screeching noise
They never leave their places
Intelligent sobriety
Is written on their faces.

The days roll by at Westminster
Mr Ford grows pale and thin.
Oft times within his Office
He will sit and stroke his chin.

They say in every human lot
There is a drop of woe.
If you would Mr Ford's discern
To Westminster just go.

22

classes with whom she circulated, this placed her immediately as an outsider, but also someone not easily pigeonholed.

This outsider status was one that Carr responded to directly and, in some cases, stridently. She emphasized rather than minimized her difference, and rather than softening her speech, mimicking cadences, soon determined that she should not lose one iota of her Canadianness. In *Growing Pains* she recounts how the ship's doctor, visiting her after some months, commented that her speech now showed the influence of Englishness. In a letter at the time, she wrote to reassure old friends that they would not see such a change. "I do not think you need to own those fears which you express and which Mr Lawson in writing to me mentioned also that I would be quite weaned away from my native land."[32] Indeed, Emily assumed the mantle of Canada and became an advocate for her country, for the place she herself called *home*, and in so doing developed a cultural perspective that challenged her new English friends who believed in the greatness of London and its situation. Her stories in *Growing Pains* reinforce this position; it was obviously a key response to her time in England. She developed her own persona, emphasizing her difference and relishing in comparison. While she accepted the metropole and its arts, music, entertainments and refined opportunities, she was not wholly converted to its charms.

Carr later recalled the extreme loneliness of living in London although surrounded by opportunities and a busy schedule. "I ached with homesickness for my West though I shook myself, called myself fool. Hadn't I strained every nerve to get here? Why whimper?"[33] England, the class-based society, Londoners, the big city itself and its dirt and poverty, the separation from the natural landscape, and the geographical distance from family would all have been fundamental adjustments, but Carr also suffered physically with a poorly healed injury to her toe, possibly the result of a carriage accident earlier in the year prior to her departure. "A dislocated toe, a split bone – results of an old injury" made exploration and normal walking an increasingly agonizing experience, as she clearly related in *Growing Pains*. Early in 1900 a London doctor amputated the toe, but "the foot went wrong. I suffered cruelly."[34] After bed rest and a surgical support in her shoe, the pain slowly receded, although standing for periods would prove to be difficult, and she always carried with her a small stool for support.

But Emily was also sick at heart. Having just settled into routine at the art school in early October 1899, she received the sad news from home that her brother, Dick, had succumbed to his illness and died a month ago in a sanatorium in Santa Barbara.[35]

32 Emily Carr to Mary Cridge, 7 May 1901. PR76, City of Victoria Archives.

33 Carr 2005, p. 124.

34 Carr 2005, pp. 152 and 153. Arthur Corrie Keep (born 1862), a cousin of Marion Redden listed in the 1901 census as a "consulting and operating surgeon", performed the surgery with Redden's authorization on behalf of Carr's family.

35 Dick died on September 5, 1899, and was buried in Victoria on September 16. *British Colonist* September 6 and 16, 1899.

Westminster School of Art, 1899–1900
Emily Carr, watercolour and ink on paper;
PDP06152.

It came as a blow. By the time the letter arrived, Dick's body had been brought home, a public funeral held, followed by burial in Ross Bay Cemetery. The local newspaper reported the event, noting the pall bearers, all his school chums and neighbourhood friends. He was just shy of 24 years and in many respects had been a special sibling, sharing Emily's enthusiasm for raising wild birds and enjoyment of tennis. He was gone, and she hadn't known. A few months later in a letter to her close Victoria friend Nellie (Cridge) Laundy, who had written with condolences, Carr revealed her state of mind: "Thank you ever so for your kind letter which made me laugh & cry in turns and the dear little hankie which was all handy to dry my eyes on." She then sat up straight and provided her friend with a frank assessment. "Well Nell, isn't it queer here I am sitting down in London just as thou' I'd sat here all my life. It was a bit awful at first I will admit & then I was so sad too about poor Dick, it was a dreadful blow to me we thought he was better, somehow you never give up hope while there is life…."[36]

Dick's death timed with Emily's absence from home has never been assessed in examining Carr's experiences in England, and in the effect it must have had on her performance, her state of mind and her own confidence. Dick would later feature in her books, but as a perpetually young blonde-haired boy, her companion and confidant, not a young man who died at 23 and whose life had been dominated by ill health and lingering weakness. In fact, Carr's lack of references to her brother in her books has created a vacuum. Most of her biographers ignored his existence and the influence he had upon her, which has underplayed the impact of his passing. Emily and Dick corresponded regularly when he was at school. One letter from 1890, when he is 14, reveals a chatty sibling intimacy as Dick gossips about Victoria neighbours, provides advice about purchasing tennis rackets and references the frequency of their letters by beginning his with, "Here beginneth the last letter of the second series."[37] Dick's death wracked Emily with guilt, with remonstrations that she should have known, perhaps should have been with him. When her sister Edith, therefore, sends a few mementos to Emily, she appreciates the gesture and the generosity. "Thank you ever so for the parcel I am very glad to have Dick's things. I am afraid I have the lions share."[38]

As it turned out, Emily was also in correspondence with Mayo Paddon in Victoria, who did not let the distance between them curb his romantic interests. She gave little encouragement and tried to dissuade him, but he would not let go. Dealing with his clinging affections, even from afar, was a chore, for she was not a callous sort. The strain of Paddon's love also contributed to a melancholy.

Carr arrived in England with letters from friends and family in Victoria that introduced her to friends and family in London. It was the way people networked, but for her it felt awkward and when she did contact some of the names, her

36 Emily Carr to Nellie Laundy, 19 January 1900. City of Victoria Archives.
37 Richard Carr to Emily Carr, 14 May 1890. MS-2763, BC Archives.
38 Emily Carr to Edith Carr, 19 September 1900. MS-2763, BC Archives.

experiences were not always positive. Although she maintained in *Growing Pains* that, as a result, she burned many of these letters, close reading of her correspondence and unpublished manuscripts, combined with use of the 1901 census, reveals she did follow up on more than a few introductions and was socially active with a selection of people connected to Victoria – people from Victoria either now living in England or who visited during her stay. In so doing, she developed a rather broad group of friends.

Her most significant friend and supporter was, as Maria Tippett uncovered, Marion Redden, a widow (the Mrs Radcliffe who Carr writes about in *Growing Pains*). She and her son Frederick, just five years older than Emily,[39] were expatriate Canadians from Ontario, which endeared them to Carr who became, as mentioned, fiercely patriotic while overseas. Marion Redden was the aunt of Victoria friends, and unlike most of the seemingly obligatory introductory letters Carr was provided with upon her departure, Mrs Redden was mentioned with overflowing recommendations. "Go and see Aunt Marion", Carr's friends encouraged. Their "faces sparkled at her mention". Upon meeting Emily, Marion Redden told her: "I've heard all about you from my nieces." And then she received Carr "as you accept a letter from the postman. It may contain good. It may contain bad."[40] Redden and her circle would become Emily's replacement family; they were loyal and supportive, shared her ups and downs,

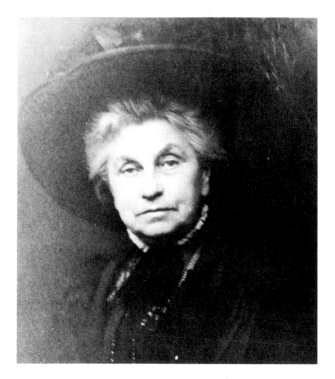

Marion Redden, Carr's friend and mother figure while in London.
Unknown photographer; from Tippet 1979.

conducted honest and open conversation. Years later, when hearing of Marion Redden's death, Carr wrote to Fred: "how good she was to me … the very first friend I had in England when I was rather a miserable little student and sick & lonely."[41]

Carr writes also about Mrs Denny and her son Ed, who were, in reality, Sophia and Edward Mortimer. Edward was the youngest of four children and had moved with his widowed mother from Ontario to London, leaving siblings in Canada. He would later return to live in Canada. She also wrote about Redden and Mortimer's friend Samuel Blake and for reasons unknown (perhaps because she did not say anything unkind about him), did not

39 Frederick Arthur Corey Redden was born in 1866 in Ontario.
40 Carr 2005, p. 134.
41 Emily Carr to Frederick Redden, March 1917. Photocopy in Edythe Hembroff-Schleicher papers, MS-2792, BC Archives.

disguise his name. In the 1901 census, Edward Mortimer is listed as a "Journalist". Fred Redden and Samuel Blake had each graduated from Osgoode Hall before moving to London; Redden is listed as an "Articling Solicitor", and Blake a "Barrister and Privy Council agent". Redden and Blake would soon become partners in a law firm and go on to co-author two books on specific aspects of Canadian law overseas.

Carr was bold enough in later years to claim that Fred Redden was middle aged, when he, Ed and Sam were only five, six and three years older than her.[42] With these three men and family members present within Carr's circle, plus several expatriate Victoria residents with whom she interacted, Carr's conviction that she was alone without the solace of fellow Canadians is untrue. In emphasizing themes of isolation and aloneness in her public writing, Carr created and cultivated in *Growing Pains* a quasi-fictional persona bereft of social interactions with people her own age. Perhaps it was this intention that motivated her to change their ages in her stories. If she cast these men as older, as middle aged, it would emphasize her aloneness, appearing to have less social interaction with peers. It would then all fit the persona created in her public writings as she fashioned and wove her personal story with real and emphasized life struggles.

As she did with the Reddens, Emily Carr altered personal names and details of the Mortimers, yet Blake's name and details are unchanged. The rationale for why she did and did not fictionalize personal names remains unclear and has been the subject of some speculation. As research progresses through consultation with historical sources and the correct surnames are discovered, it appears that, although fictionalized in appellation, the personalities in *Growing Pains* represent real individuals. Carr did not use fictional tropes, did not invent people for the sake of storytelling, but for unknown reasons thought best to disguise their true identities.[43]

Carr's time in London would have been very different had she not created ties with these transplanted Canadians who made her feel at home in their company. They shared national identification, and despite their living situations and longer-term familiarity with London, the Reddens and Mortimers were still colonials. Their acceptance of Emily's Canadian outlook and habits provided relief to her from the class-embedded perspectives of her English acquaintances, who were always seeing her as "other". Friendship with the Reddens and Mortimers allowed her to relax.

Marion Redden appears to have been many things to Emily: a mother substitute, a woman of strong character who provided positive support and encouragement, a person of patience and sharing who brought Carr into her circle without hesitation or second thought. Emily worked hard all week, and on Saturdays and Sundays left her studies behind. The two established a routine each Sunday attending church services at St Paul's Cathedral, followed by afternoon tea at the Redden home and then often evensong

42 Edward Mortimer was born on December 4, 1865, Ontario, and Samuel Blake in 1868, also in Ontario.
43 See Elderkin 1992.

at St John's or another smaller church. The Reddens and Fred's friends included Emily on various sightseeing trips, such as rowing along the Thames, visiting art galleries, and attending concerts and other entertainments. She mixed easily with this crowd because of their Canadian connections, and with several other expatriate Canadians and Victoria people visiting London who she names specifically in letters home. "I saw the Langleys a bit back, it was delightful to see home people & Mr Fowler too, his mother is so nice I have been there several times it is a bit out of London." She also visited three generations of cousins, then living not far from her, and spent several weekends as the guest of former Victoria residents George and Sophia Langford (brother and sister), who lived in Dorking. We do not know for certain if she met up with fellow Victoria artists Theresa Wylde and Sophie Pemberton, but Carr did say in one letter, "I have not seen anything of Sophie."[44]

But it was the Reddens and their close friends who figure in her writings, and it was in their company that her nickname, Klee Wyck, was encouraged, for it featured in Carr's telling of her time at Ucluelet earlier that spring. It became the name they always used for her. In the decades following her return from England, she continued to sign her letters to the Reddens "yours sincerely, Klee Wyck." She gave the photograph on page 25 to Marion Redden with the inscription, "To Mrs Redden from Klee-Wyck."

The fascination the English had with the North American West gave Emily an entrée into London conversation. It also allowed her to create her own persona, that of a colonial whose character was shaped by a wild and untamed landscape on the edge of the empire and whose experiences included living among indigenous people. This was not entirely accurate – in reality, Carr had many interactions with First Peoples, but they were fairly limited.[45] During her childhood "it is estimated that there were nearly as many Natives in Victoria itself as there were whites."[46] First Nations people were visible on the streets of the city, on the beaches at Beacon Hill and also at the Songhees village across James Bay, not far from the Carrs' house. The Carrs employed an aboriginal washerwoman named Mary, and Richard Carr sold supplies and provisions to First Nations clients in his store. The demographics changed dramatically during Emily Carr's lifetime. In 1871, the year of her birth, First Nations represented 71 per cent of the population in BC, but by 1901 it was only 16 per cent.[47]

Carr's observations would also be informed by Christian missionaries administering to First Nations in the field who "reported back" at her church or via public lectures and social events. Certainly Carr would have seen missionary tracts in the house, and missionary friends of Lizzie who came to visit would naturally discuss their interactions with First Nations. Anthropologist Franz Boas visited

44 Emily Carr to Nellie Laundy, 19 January 1900. City of Victoria Archives.
45 Moray 2006, p. 38.
46 Tippett 1979, p. 28.
47 Barman 1991, table on p. 363.

Victoria on several occasions beginning in 1886 and presented public lectures. His *Chinook Texts* appeared in 1894. Gerta Moray states that Carr did not meet Franz Boas "although they narrowly missed each other on several occasions."[48] Nevertheless, the Carr library may have included printed material that yielded information for an impressionable girl already at odds with aspects of the settler-disconnect from the natural environment and from its aboriginal inhabitants.[49]

Carr's friends in England assumed she was different because she had been born in Canada and was unused to British ways. This not only set her apart in their minds (reading her stories we see specific episodes) but also provided her with an excuse for being different – legitimized her individuality and perceived eccentricities. But with Marion Redden, a special bond might also have been in play and she may represent a new link in our understanding of Emily Carr's uncommon receptiveness to First Nations peoples and cultures. Marion Redden, née Sproat, was born in Ontario and lived there until her husband's death in 1872, but her family roots were in Scotland. One of her Scottish cousins, Gilbert Malcolm Sproat, emigrated to Vancouver Island in 1860, a year or so before Richard Carr. Like Carr, Sproat was a merchant with commercial ties in San Francisco. In fact, his establishment was next door to Richard Carr's wholesale provisions store. It is possible that Sproat and Carr's father socialized. Victoria was a small town in the 1860s. Sproat had three children who were just a few years older than Emily Carr. In 1868 he published *Scenes and Studies of Savage Life*, based on his experiences while in Alberni Inlet at a lumber mill he ran. A book such as this may have been on the shelves of Richard Carr's library or otherwise been available to Emily while growing up. But the family moved to England and it was not until 1891, at least, that the two Sproat boys returned to BC. In the 1891 census, Gilbert junior is resident in a boarding house in downtown Victoria. Perhaps it was he who suggested his father's cousin as a contact in England.

Gilbert Sproat senior returned to BC as an Indian Reserve Commissioner in 1876, a position from which he was eventually removed because of his views, which were decidedly different from the prevailing settler perspective that the land was free for the taking. "His correspondence during his time as reserve commissioner stand as a voice of opposition to the disregard of Aboriginal rights, the unjust treatment of Indigenous people by the governments, and the 'settlement' of BC."[50] All these were views contrary to the opinions held by most settlers and government officials.

48 Moray 2006, p. 59.

49 She may also have received specific anthropological information via conversations between her father and his circle. Richard Carr was not unsympathetic to the plight of First Nations people, of the negative impact of the settler society upon their social and cultural traditions. His early travels in South America and a sojourn in California during the 1849 gold rush left him with no doubt as to their spiritual and economic devastation. Bishop Hills of the Church of Our Lord, where the family worshipped advocated equality for the Black population and probably affirmed the dignity of First Nations.

50 Sproat visited with settlers who had collections of artifacts, or who were strategic contacts. Moray (2006) names Bishop Hills as one. It is not difficult to speculate that perhaps while visiting Maud or Nellie Cridge at Marifield she might have come into contact with him there visiting Bishop Cridge, or attended a lecture. More biographical information on Sproat can be found at jirc.ubcic.bc.ca/node/46.

As an elderly man, he moved to Victoria in the mid 1890s and resided on South Park Street, around the corner from the Carr home. He continued to be a dissonant voice in the newspapers and publications. Whether Emily read his views, or whether the Carr family interacted with the Sproats, we do not know at this point, but the situation of Sproat's cousin becoming Carr's close friend in London begs a connecting factor. Three degrees of separation in a town the size of Victoria and a city as large as London is not coincidental.

The other connection to Sproat is related to Carr's own story of how she acquired Klee Wyck as her nickname. She offers the translation as "Laughing One". As she explains it, her smiling and positive gestures when trying to communicate across language and culture barriers during her stay at the mission in Ucluelet had inspired the people there to give her that appellation. Sproat's book, *Savage Life*, contains a vocabulary of "Aht" or Nuu-chah-nulth words. It lists the verb "to laugh" as *kleehua* and the word for "not I" as *wik* – together these two words, spelled as "Klee Wyck" seem to mean "someone who is not the observer laughs". Coincidence? Another language book, *The Takhaht Language* by missionary C. Knife, published in the same year, similarly lists the words. If Carr had access to *Savage Life*, which seems likely, or if she knew Sproat, which seems probable, she very well might

have tried to legitimize the nickname given to her verbally through a cross reference.

Marion Redden's friend Sophia Mortimer was generous with her time and determined to acquaint Carr with all the nooks and crannies in London. Mrs Mortimer, according to Carr, "always had Baedeker under her arm", demonstrating how, as a non-native Londoner, she employed that famous guidebook to learn how to navigate the city and locate all the "national astonishments, great sights, picture-galleries".[51] She now introduced them to Carr. Together the two explored and Carr learned to navigate her way around the city. Mrs Mortimer held convictions on many topics and made a good attempt to change Carr's direction, often tossing her hints about the suitability of her son Edward as a husband. Such a romantic match was not to be. Carr made it clear; she was in London to hone her craft, not to look for a husband, despite the clear interests of two other men who travelled to London specifically to further their interests. Carr recounted the stories of both men and their visits to her in *Growing Pains*. Wycliffe Waddington (not Piddington, as Carr wrote) was the brother of close friends to her sister Edith who had acted as Emily's "protectors" while in San Francisco.[52] A railroad buff, he came from Liverpool initially to stake his intentions. His visit clearly demonstrated their incompatibility and, as Carr relates, both were relieved the visit was a singular

51 Carr 2005, p. 191. Baedeker was a major publisher of guidebooks during this time.
52 James Franklin Waddington and his wife, Amelia, lived in San Francisco and visited the Carrs in Victoria. They feature as the Piddingtons in *Growing Pains*. See Edith Carr to Flora Burns 5 April 1891; MS-2786, BC Archives. San Francisco directories list the Waddingtons at the Geary Street address shared by the Carr sisters.

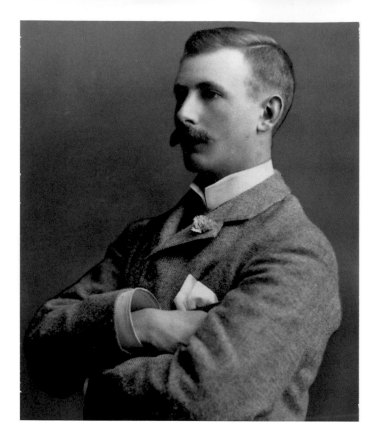

Mayo Paddon, 1901.
Unknown photographer; private collection.

stuck in a heap by being grabbed by the hand by Mayo Paddon on the platform. He had been to see me at Mrs Dodd's & she told him I was coming by that train it was nice to see a home face again."[53]

Carr devotes a chapter in *Growing Pains* to Paddon, his visit, the outings and excursions undertaken, the visit to St Paul's Cathedral complete "from Dome to Crypt" and of her repeated rejections of his weekly marriage proposals. It was just a week before art school reopened and Carr focused on beginning her studies, so entertaining a suitor interfered. She tried to dissuade Paddon from his suit and each time he proposed, said no. Eventually he realized she would not relent and so returned to Canada. Paddon's diary records over subsequent months his hopeless anguish. On January 31, 1901: "Have felt so utterly wretched and lonely ever since arriving home but I have asked her now for the last time if she will let things be as they were before. Why should my love kill our friendship?" Finally, on March 18, he received a letter "which ends it I suppose."[54] Carr's letting go was not without its guilt. "I did it in self defence," she wrote later. "I am *glad* I obeyed my heart and am me still." "I *do* not think I made a mistake. To be married without love would be hell…. Where would Small & Klee Wyck have gone?"[55]

Carr's telling of his visit includes details that broaden our understanding of her awareness of Londoners less fortunate, and perhaps the influence that Paddon had

one. Carr also referenced a visit from the young "Irish doctor" from her Atlantic voyage. Like Mayo Paddon, neither met with encouragement.

But in September 1900, when Mayo Paddon unexpectedly arrived in London from Victoria, having taken a three-month's leave of absence from his employment, both Marion Redden and Mrs Mortimer connived to push Paddon's interests. Carr was not expecting him. He was there to meet her at Euston Station as she returned from a visit to Scotland. "I got back last Saturday night 9 o'clock & was

53 Emily Carr to Edith Carr, 10 September 1900 (this and the next quotation). MS 2763, BC Archives. The letter contains more details of Paddon's visit.

54 William Locke "Mayo" Paddon's 1901 diary, private collection.

55 Carr 2006, p. 227; and Emily Carr to Ira Dilworth 10 January 1942 and about 30 December 1942, quoted in Morra 2006, pp. 96 and 184.

on her in invoking a social conscience. Carr stated that history always bored her, that she did not favour book learning and that she knew more about London and England itself from reading the novels of Charles Dickens.[56] In these comments she was not alone, nor was she unusual. In fact, most of the knowledge held by London's middle and upper-middle classes about London's poor was also gained through Dickens. Reformers focused on the plight of the Little Nells and Oliver Twists to garner support for a variety of philanthropic causes. The unfortunate poor – the abysmal living conditions and the degradation attributed to alcohol and other vices – were popular targets of paternalistic, albeit well meaning, middle- and upper-middle-class reformers.

From 1899 to 1901, Carr, the Reddens and the Mortimers established a routine of Sunday service at Westminster Abbey, followed by evensong at nearby St John's, both churches under the authority of Basil Wilberforce, scion of famed reformers, William and Samuel Wilberforce. Basil Wilberforce held the positions of canon of Westminster Abbey and rector at St John's church. The two venues enabled him to have different presentation styles. At the abbey the sermons were on topic but less rousing than those at the smaller church. A renowned orator, Wilberforce spoke with passion and conviction to both the well-heeled gentry of London at Westminster and the largely middle-class female parishioners at St John's about many topics, including social reform. He advocated a lifestyle of temperance, believed in anti-

vivisectionist policies and supported the feminist movement.

When Mayo Paddon visited Carr in London, she took him to hear Wilberforce speak. Paddon's father was an Anglican minister, and Mayo might have already supported the canon's views. It was certainly an opportunity for him to listen to Wilberforce, who was also well regarded in Victoria.

When Wilberforce called for district visitors in the parish, Marion Redden persuaded Carr to volunteer in the parish of St John's, the small "unfashionable old church" that these two were especially attached to. She was one of several parishioners who would visit the households of the slum poor, take small gifts of food, and keep up to date on the health of each family. Although Carr confesses that she did not believe herself suited to the work, the fact that she agreed to undertake it, and did so for a period of several weeks running, reveals that she was not indifferent to the poor and was prepared to perform duties considered appropriate for a woman of her social standing. One day, as she relates in *Growing Pains*, she was asked by a poor family to inform the curate of an ailing parishioner. This she did, at the end of her rounds, finding out where the curate lived and then knocking on his door. This was an unfortunate faux pas, because she should have reported the situation at the church house, as was the practise. She had no idea that visiting a man in his rooms, even a curate, even for a worthy reason, would be inappropriate in London. The

56 Carr 2005, p. 121.

response to her arrival there by the curate's housekeeper should have alerted her, but it was reporting to Mrs Redden afterward that confirmed her error. She was chastised and embarrassed, and she refused to continue with the visits or attendance at St John's because she felt unable to face the curate.

Carr's various experiences with clergy, her assessment of their character and convictions appear in several of her books. The family in Victoria attended two churches, one favoured by her father and the other by her mother. Although she held great affection for Bishop Cridge in Victoria, she was less enamoured of Dr Reid of the Presbyterian Church there, and was intensely sensitive throughout her life to hypocritical behaviours exhibited by church representatives, including missionaries, and also of church-goers generally. In Victoria she witnessed the divides between high and low church (which had created the separate establishment of her own Church of Our Lord), and between Anglican and Catholic believers intent on undermining the other. So when she came to England and Mrs Mortimer commented that Emily ought not to wear her mother's little carnelian cross because "it savours of R.C.", her disillusion appeared well founded.[57] She was intensely aware – having plenty of experience living with a pious sister, Lizzie, and observing sister Edith's social set, as they fundraised for charities – that many who professed Christian principles did so at the expense of life's own joys. In particular, Carr had no patience for those who condemned the pleasure she found in music, in art and culture. When in England she gave up a weekend to undertake an obligatory visit at the house of "friends of friends", she found the family completely dominated by the opinions of three visiting fundamentalist South African missionaries. None, to her amazement believed Handel's *Messiah* to be sacred, in fact quite the opposite.

Despite her own clear faith, Carr had several experiences that challenged a unilateral acceptance of Christian behaviour. Episodes in *Growing Pains* reveal that one clergyman fondled her thigh in church, while another refused to believe she was Canadian because she was unfamiliar with cities in the eastern United States of America. Churchgoing itself, connected so intimately with the character of clergy, became, over time, less a part of her weekly routine than previously, and eventually encouraged an independent spiritual life.

57 Carr 2005, p. 137.

Lessons in Art and Life

When Emily enrolled at the Westminster School of Art she planned to attend classes that would challenge her technically and improve her skills. Three years at art school in San Francisco prepared her to move away from the standard still-life exercises or copying from the antique. The whole reason for coming to England was, after all, to learn and to advance her art, not to repeat the familiar. She therefore boldly requested registration in a class that specialized in drawing from the nude. It was a segregated class for women students, which ensured social propriety and diffused awkwardness. It attracted Carr because she had yet to draw from the nude; her previous figure studies involved clothed models. For female artists, the experience of drawing from the nude differentiated the amateur from the professional, the dilettante from the serious student. It was therefore a big step, one that proved transformative, shaking the foundations of her own attitude to physicality and replacing it with a reverence for the human form that she saw as spiritual. "I had never been taught to think of our naked bodies as something beautiful, only as something indecent, something to be hidden.... [The model's] beauty delighted the artist in us. The illuminated glow of her flesh made sacred the busy hush as we worked."[58]

In *Growing Pains* she commented on the standoffishness of her fellow students, a contrast from the easy friendliness she had experienced in San Francisco. But she soon made one fast friend – Alice Watts, from Wisback, Cambridgeshire, a clergyman's daughter – and by the beginning of the second term in January 1900, Carr was feeling a little more at home. That month she confessed: "I hated every jack man of the Englishers at first – strong cold blooded monsters.... Well now I like it ... & the students have shifted their strangers treatment onto other luckless new comers they have the name of being hateful to strangers & glory in it.... I like some of the students now they are very queer but are nice enough when they once condescend to bend."[59]

Alice Watts (as Alice Watkin) figures predominantly in *Growing Pains*. She and Carr shared lodgings, walked to the

58 Carr 2005, pp. 132–33.
59 Emily Carr to Nellie Laundy 19 January 1900. City of Victoria Archives.

Westminster School of Art together and enjoyed each other's company. They had points in common: both had lost their mothers, both had much older siblings and were mothered by elder sisters, both had moved from their homes to attend art schools. Alice's father, over 70, was an Anglican minister, still preaching in Cambridgeshire. He was a bit of a parallel for Edward Cridge, the elderly minister of Carr's Victoria church and father of her close friend Nellie. For that first year, Alice Watts was the confidant and companion Emily needed. Emily admired Alice's matter of fact outlook, compared her own behaviour to Alice's and gained confidence through such example. When times were tough, Carr wrote, she took inspiration. "Alice would never have cried.… She would have squared her chin, stuck her high-bridged nose in the air.… English girls were frightfully brave.…"[60]

Carr's stories add a decade to the age of Alice's father and exaggerate his frailties as a means to illustrate the tender oversight of his daughters. She also plays up the responsibility the family undertook in continuing to support and care for their aging servants. Through this relationship with the Watts family Emily learned more about the interdependence of the middle and working classes, and also that ties of affection and familiarity could create emotional bonds that challenged some of the assumptions she had made regarding class relations among the English. She was not just skimming the surface in her personal relationships but making deep ties that would last a lifetime, creating and holding memories that would much later bubble to the surface in written vignettes.

Carr gives Alice seven older brothers (in reality five), each of whom – as society expected – had to be educated, established in careers and married, a huge financial burden that certainly stretched the income of an Anglican minister and left little extra for the girls. Alice, born in 1876, had a sister 23 years older than her, and another 6 years older, both of whom remained unmarried and at home, perhaps in response to financial necessity – not an uncommon situation for upper-middle-class women who performed domestic tasks and ran the household as a family strategy to economize. "Why don't they do a bit for you girls now?" Emily asks in *Growing Pains*. Alice responds, "Mother brought us up that way – the boys always first. The boys have wives now." The implication was that this support would not shift. In Carr's story she states that she is glad to be Canadian, intimating that such gendered unfairness was not the practice in her home. But of course it was. Her own brother was educated at elite boarding schools away from Victoria, and her childhood years were coloured by the reality that young boys from local upper-middle-class families like hers were removed from their homes and sent away (often overseas) for educations. Later, when these boys returned as young men, they moved into apprenticeships and articling situations, trajectories that moved them into adulthood having missed key adolescent growing within a family setting.[61] These family financial

60 Carr 2005, pp. 147–48.

61 For further information on this phenomenon in British Columbia see Bridge 2012.

priorities – to establish boys in careers – was a Canadian as well as a British practice. Carr's father provided for Dick's schooling but did not settle his daughters with the ability to control their own finances. He set up a male guardian to administer funds for their general needs, perpetuating their lifelong state of financial dependency.

Perhaps as much as she protested, Carr saw that she and Alice Watts had much in common. Certainly Alice and her older unmarried sister shared some of the financial strains Emily experienced with her own older unmarried sisters and with the limited options this presented. Alice, like Emily, received financial assistance from her family to pursue art studies, but it was not thought of as a potential career, only as a hobby or recreational pursuit. Emily half enviously remarks on Alice's several art diplomas and certificates and her encyclopedic knowledge of the history of western art, but when Alice "won her final South Kensington teaching certificate"[62], Alice's art student days were over, because it was not socially acceptable that she use the diploma to teach. Instead, Alice was destined for a year-long visit to an older brother in India, to be removed as a dependent of her aging father to a dependent of a male sibling.

Watts's personality did not threaten or find fault. Instead, she was very accommodating and curious about Carr. She endeared herself to Carr in several ways, not the least in her attitude toward the nicknames given Carr by her fellow students. Many called Carr "Motor", an appellation Emily did not think to be especially flattering. Watts called her "Carlight", instead, even in their later correspondences, with affection: "Dear little Carlight".[63] Carr respected her friend's common sense and bravery, relied on her for emotional support. Together the friends changed residences three times. Initially Carr moved from Miss Green's because the distance was too great to travel each day to art school. She then "took a room in a house on Vincent Square where two other Art School students lodged," one being Alice Watts, the other "the disagreeable head of the Life room."[64] But while the location was much closer – and less strain on her injured foot – the situation was not amenable. Meals came entirely without sweetening, as the "disagreeable student was on a diet", and the landlady's sitting room where Carr was expected to eat breakfast was below street level – its window "looked into a walled pit under the street which was grated over the top…. The air was foul." But worst of all was the situation of Carr's own room, with a view "that was far from nice." She looked directly across a narrow yard into a cancer hospital. "Nurses worked with gas full on and the blinds up. I saw the most unpleasant things."[65]

Soon the landlady's drinking and abusive behaviour prompted another move, this time to a place found by Marion Redden, not far from her own home on Cambridge Street. Carr and Watts transferred their belongings and set themselves up for a few months, until

62 Carr 2005, p. 166.
63 Alice Piper to Emily Carr, 7 August 1910. MS-2763, BC Archives.
64 Carr 2005, p. 144.
65 Carr 2005, p. 148. The Gordon Hospital stood opposite Carr's bedroom on Vincent Square.

term break, when Watts moved home to Cambridgeshire. By May 1900, Emily had moved once more, this time to a place that satisfied her, where she would reside longer term, with a landlady for whom she soon held affection. She later recorded her experiences living there in the series of sketches and verse titled "A London Student Sojourn", presented here for the first time.

Mary Dodd and her husband, Albert, ran the boarding house at 4 Bulstrode Street. Mrs Dodd appears to have genuinely enjoyed being a landlady, and took an interest in her boarders and their needs. She and Carr began a long-term association that would continue more than a decade later, when Carr stopped in London before and after art studies in France. At Bulstrode Street female boarders lived dormitory style on two floors in small cubicles – created by flimsy curtained walls – that were barely sufficient to accommodate a bed and a few necessities. In September 1900, after several months of living there, Emily wrote to her sister saying, "don't possess a chair there is only one between five of us. My cubicle is 2 x 2 but I have a personal window."[66] Cubicles opened to a central curtained hallway. There was little pretence to privacy and great need for mutual cooperation, as the common area of the hallway held the washstand (water needed to be carried upstairs in a pitcher), an ironing station and a mirror. The boarders shared two large sitting rooms on the ground floor, "one was talkative and had a piano, the other was silent for writing and study".[67]

Years later when writing *Growing Pains*, Carr playfully recalled the boarding house and its inhabitants and probably used "A London Student Sojourn" to refresh her memories. This "funny book" dates from 1900 to 1901 and is the earliest known of these special productions. In the later funny books, Carr wrote the verses by hand, but these were typed, probably by her cubicle friend, Beatrice Hannah Kendall, employed in London as a secretary, because Carr had yet to learn typing. "A London Student Sojourn" begins on page 38, complete with Kendall's typed rendition of the verses. Kendall also features strongly in the book. The verses and 21 coloured images capture the convivial, the trivial and the dramas, as well as the personalities of the women with whom Carr shared this intimate living space. We learn of arguments concerning windows open or closed, about snoring and sewing, of cleaning shoes and curling hair, but we also learn of flexibility and emotional support, sharing of chores and mutual assistance. The women were diverse in age and occupation. Each was in London and on her own for different reasons, under different circumstances, and it was an international cohort. Of the forty women enumerated in the 1901 census as boarders, only six were listed as "living on own means" and four as students. All were unmarried. Carr's companions included Swiss, German and French governesses, two Swedish masseuses, Irish and Portuguese nurses, an American secretary, two French dressmakers, and women from the Scottish and English countryside who worked as secretaries, milliners and nurses. A woman named Helen R. Jones was listed as an artist, perhaps one of Carr's fellow students

66 Emily Carr to Edith Carr, 10 September 1900. MS-2763, BC Archives.
67 Carr 2005, p. 193.

at the art school and her connection to the boarding house.

Emily's choice of residence at 4 Bulstrode Street reveals the self-confidence she had gained to be on her own. She no longer needed to operate in a world delimited by letters of introduction to enable social connections as she had when she arrived in England. But it also reveals the reality of her financial budget. She intended to be in England for several years of intense training, and she needed to economize to survive. Moving into a boarding house intended for middle-class women of modest-yet-respectable situations enabled her to do so while remaining in her own social set. The women at Bulstrode Street were all like Carr, in London from somewhere else and for a purpose – to earn a wage, to benefit from training, to make their livings. Like Carr, most had tight budgets and were willing to inhabit cubicles and share.

The 1901 England census reveals the names of Carr's fellow lodgers and helps to identify with correct surnames some of the personalities in *Growing Pains*. For instance, the young woman who wore the cherry red hat is Marie Hall, living at Bulstrode Street "under special arrangement" as she was on her own, just 16, taking violin lessons. In 1905 she would tour America and Canada. "Kindal" or "Kindle" is that young secretary Hannah Kendall. The quarrelling Scottish sisters are Elizabeth and Jane Potts, and the German governess – one of a number of foreign nationals– was Martha Dryer.

We have less tangible evidence for her experiences at art school in London. The records of the Westminster School of Art have not survived, so verifying the names of instructors, fellow students or of class descriptions is difficult. Carr wrote very few specifics about the instruction she received, focusing instead on her time in and around the classes themselves. Uncertainties of who taught prevent clear comment on the quality or topicality of her classes. We are left with the rhythm of the class schedule for the school, which operated in terms from September to December, with a break over Christmas, and from January to March or April, with a break over Easter. Carr's artistic activities outside of class are easier to ascertain as she has left direct comments in *Growing Pains* and references in letters. For instance, in *Growing Pains* Emily writes that, at Easter 1900, she asked Marion Redden: "is there a little village that you know of where I could go and be in real country?" Redden suggested the village of Goudhurst in Kent. This was apparently Carr's first foray into the English countryside, and she enjoyed it immensely. It was spring, and the birds sang, the sky was glorious, the air fresh and invigorating – just the tonic she needed after a winter of big-city living. Emily wrote, "There was another student in the school who came from Victoria. She decided to come to Goudhurst for the holiday, too."[68] The vacation provided the opportunity to work *en plein air* as she had while in San Francisco. Little else is confirmed about this first excursion.

68 Carr 2005, p. 171. Although scholars suggest that this student might be Theresa Wylde, no firm evidence to date reveals such. Wylde is enumerated in the 1901 census as resident in Alexandra House, South Kensington, London, a rather more discriminating level of accommodation than fit Carr's budget.

Continued on page 82 37

P R E F A C E

When you are a lonely student
 And you come to London Town,
And you seek you for a lodging,
 Weary wandering up and down:
Some you find are very dirty,
 Some too small, and some too large,
Some unpleasantly located,
 Some but poor, yet high their charge -
Turn you then from weary seekings
 Into little Bulstrode Street,
Short and wide and quiet it lies,
 But the students need supplies;
Pause you then at number four,
 Ring and maid will ope the door,
Here a refuge you will find
 From the scuffling humankind.
'Tis not luxury and ease,
 'Tis but living in a squeeze.

TB758

A London Student Sojourn
Emily Carr, gouache on paper, 1900–1901; PDP06096-06116.

Six by six feet is your space,
 Room to sleep and wash your face -
Sittingrooms of course below,
 Where for study you can go.
Curtains buff and red are hung
 All around, on iron rods strung;
One room in portions five divided
 Called Cubicles - when you've decided
Which on having you are bent,
 Settle there and be content,
Suffice you then nor dream of home,
 Where for miles and miles you roam,
Full of freedom, full of joy,
 Four good sisters to annoy,
Bravely face another life
 Full of hardships, rubs, and strife,
Thankful for your daily bread,
 Let your eyes look straight ahead;
Onward then, nor turn you back,
 Heed not comforts that you lack,
Know that what we here would gain
 Must be bought with tears and pain,
For what's worth having we must fight -
 Be therefore strong and seek the right.

We've all been through it once, but oh! it is not fair -

 It makes you feel so dreadfully bad the way the old
 girls stare;

They whisper and they giggle and discuss your face and
 dress,

 You never liked a cubicle, and now you like it less.

They watch to see your little ways -

 Ignore you for the first few days -

Then if you don't talk in your sleep,

 Your cubicle you tidy keep,

And are not noisy, forward, bold,

 The others will become less cold,

And soon a merry party we,

 Living together happily.

Of course sometimes disputes will rise,

 Nor is it matter for surprise -

Think - we are five, and women all!

 There must needs sometimes be a squall,

Till days shall end and time shall cease:

 Five women and Perpetual Peace!!

The thing is not to be expected,

 To say it would but be affected.

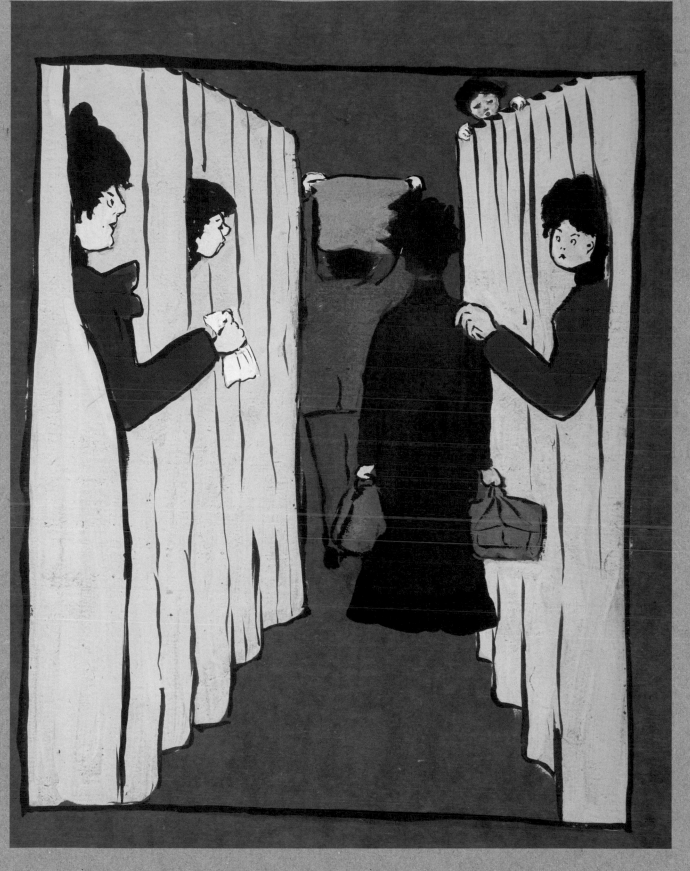

Marylebone clock strikes ten,
 The students' work is done,
To our neat little beds,
 With their cheery red spreads,
We troop up one by one.
 Ah! this is the cosy time
That the private-room girl does not ken,
 The gossip and chatter, the noise and the clatter
Of a cubicle-room just then!
 Like the owl wakes our poet to odes,
Old Pizzard discusses the modes,
 And Kindal and I munching crackers and figs,
Wash our fat faces and brush our sleek wigs,
 And oft thus discussing we heed not the time,
Till off goes the light as eleven doth chime:
 In confusion and darkness each runs to her corner,
And bumped noses and toes cause many a mourner.

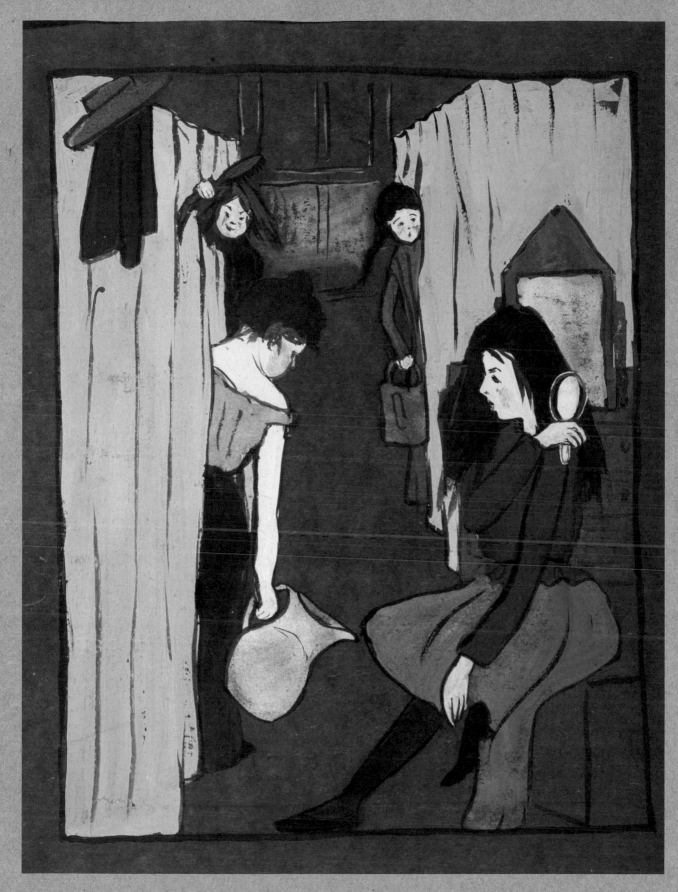

Now Pizzard does not like me,

 And well the fact doth show,

And I do not like Pizzard,

 I too that fact well know.

It happened o'er the window,

 Should it shut or open be? -

Thus strained relations came about

 Twixt Pizzard and twixt me;

And then a glassy stare she took

 Whenever she my way did look;

If she a question longed to ask,

 She would not shift this iron mask,

But speaking loudly o'er my head,

 Would ask of Kindal in my stead,

Who in her turn would ask of me,

 Thus conversation worked by three.

If I the water-can had got,

 She'd gaze about and see it not,

Though we were standing face to face

 She'd gaze as though at vacant space

And ask if Kindal saw the can -

 Who answered in the trio plan.

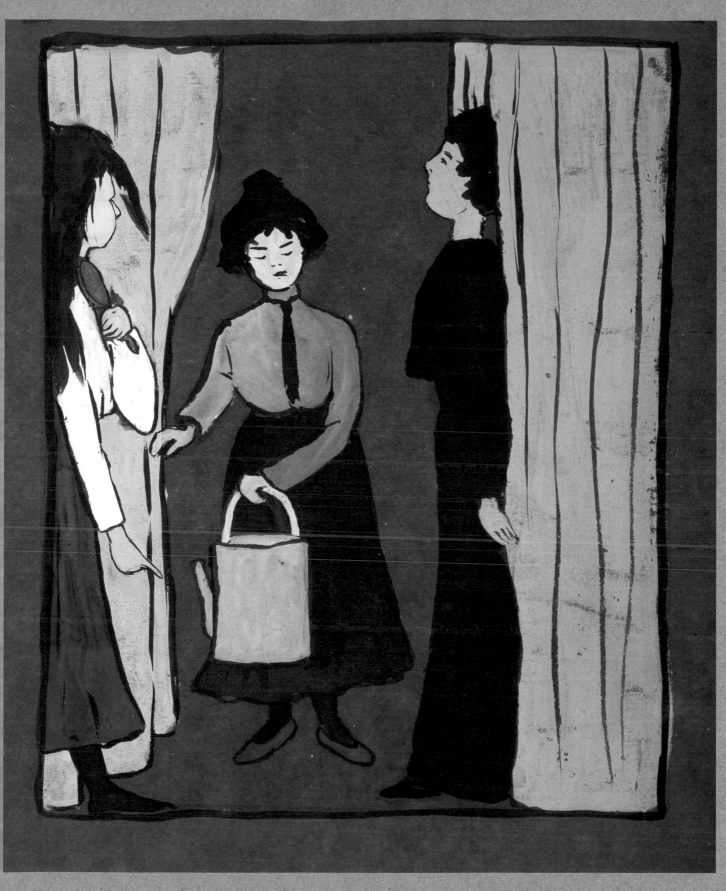

And every night it was the same
 When in from modelling-class I came -
The window tight was shut and locked,
 The ventilator closed and blocked:
After the cool night-air I find
 The room is stuffy to my mind.
The reason of it was just thus -
 The others hate to make a fuss,
Though they from lack of air keep waking,
 And wake at morn with sad heads aching.
But not so chicken-hearted I -
 With umbrella lifted high,
Open it comes, in pours the air,
 Nor for her whines and threats I care:
The others peeping from behind
 Seem untold merriment to find;
She puts it up, I pull it down,
 She whimpers soft, I scowl and frown.
And thus far on into the night
 Is carried on the window-fight.
And she who cannot keep awake
 The consequence must surely take;
I only think the girls might fight,
 For four of us are in the right,
And why should five be suffocated
 Because by one the cold's o'er-rated?

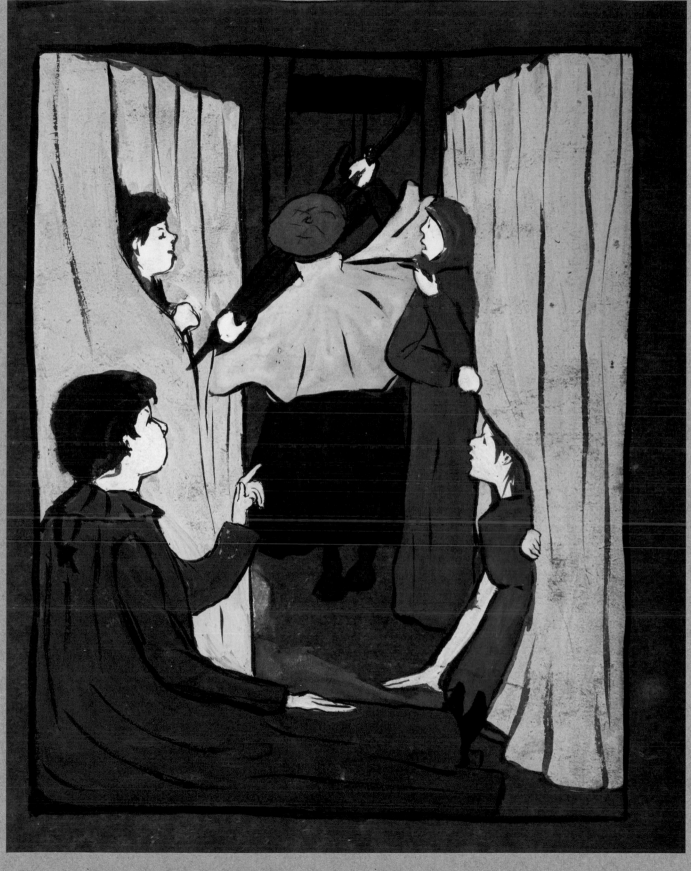

Now I invented a notion

 Which worked with excellent speed,

When that choking sensation came o'er us,

 And we felt for soft zephyrs a need :-

A spirit lamp and a stocking

 Just held in the flame for a bit,

Till the room was so full

 With the smell of burnt wool,

The old girl was about in a fit.

 In a voice of sepulchral depression

A request from her corner would come -

 " Pray open the window and let out the smoke,

" There's a smell of burnt wool, I feel I shall choke!"

 Then off to our beds and asleep in a jiffy -

Lest she'd order the window shut down when less whiffy.

Now Kindal's cubicle was so small

 There was'nt room for her glass at all,

So out in the centre aisle it stood,

 And she did her hair as best she could.

But the others found that they could see

 In Kindal's glass more easily:

They hurried to see who could get there first,

 And poor little Kindal came off the worst.

They peered over her shoulder and crowded in front

 Till the poor little thing went off with a grunt:

Fell a tear from her eye on her blue chemise,

 And she sighed - "It's so sad to live in a squeeze!"

" Cheer up, little Kindal, if you have'nt a glass,

 " At least by your bedside there's room to pass,

" While I on the top of my furniture tread

 " Before I can reach my tiny bed."

" Oh hurry up, good Carr,

 Because it's freezing cold,

My nose is all the colours

 From blue and red to gold."

So the little stove is lighted,

 And the iron upon it set:

With the flames rise Kindal's spirits -

 Life is worth the living yet!

She cuddles it till warm and cosy,

 And till her nose is much less rosy:

And then I seize it with delight,

 And go to sleep hugging it tight.

I would'nt quarrel with the space
 For being so small and snug,
If it was'nt that there was no place
 To stand the water-jug.
And every day was one kicked o'er,
 And sometimes two or three or four,
And as the floors were not too thick,
 We had to mop it up so quick,
Else through the plaster swift it sank,
 And she below you would not thank
You, if it dripped the ceiling through:
 At breakfast scolds awaited you.
So everyone with towels would fly
 To slop and mop and rub it dry;
Pizzard alone, with nose in sky,
 And peticotes turned very high,
Would saunter to her cubikettle,
 And with a book would comfie settle,
While we with genuine goodwill,
 Would hasten to each other's spill,
And down upon our knees would get.
 To-morrow we too might upset,
And as we to their rescue came,
 So we in turn would reap the same.

There is'nt a drop of water,

 And it's dreadfully, fearfully cold,

But Kindal turns out in her blue chemise -

 For Kindal is brave and bold;

The jug and the can she carries,

 And off to the tap she goes,

And brings back water for all of us,

 And we groan as we look at her nose!

And I say to myself - " For long to-night

 " She shall have the iron for her toes."

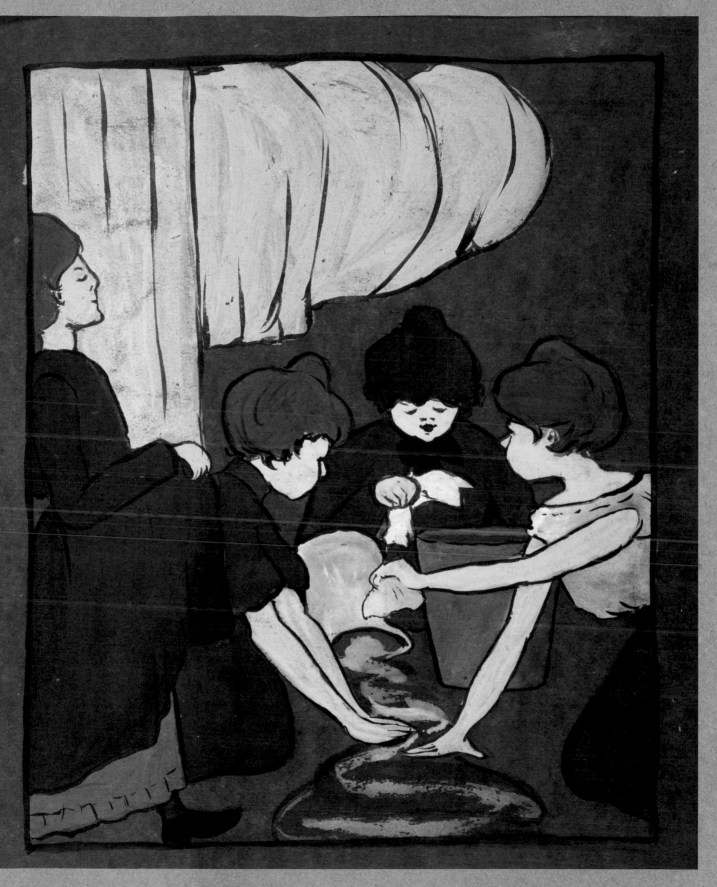

A great many girls and a very few pegs,

 She came off the best who had longest legs;

Both for height and for speed

 In the rush there was need.

T'was the last thing at night

 And the first thing at morn,

That rush for the pegs

 With the garments not worn:

T'was the keenest excitement

 To know who'd get hung,

It even extended the garments among,

 The skirts seemed to whisper in some unknown tongue.

Those crowded out in a pitiful heap

 Lay on the floor, making best dresses weep;

And Pizzard, the lady of trains and of means,

 Looked on with disgust at such turbulent scenes -

Her gowns from our gowns were kept quite away,

 For her own private cupboard sixpence weekly did
 pay,

And mid all our struggling for the window she'd rush,

 Shutting it tight with scarce audible push,

But we on returning with one voice would declare

 " 'Tis a roasting hot morning, we must have some
 air!"

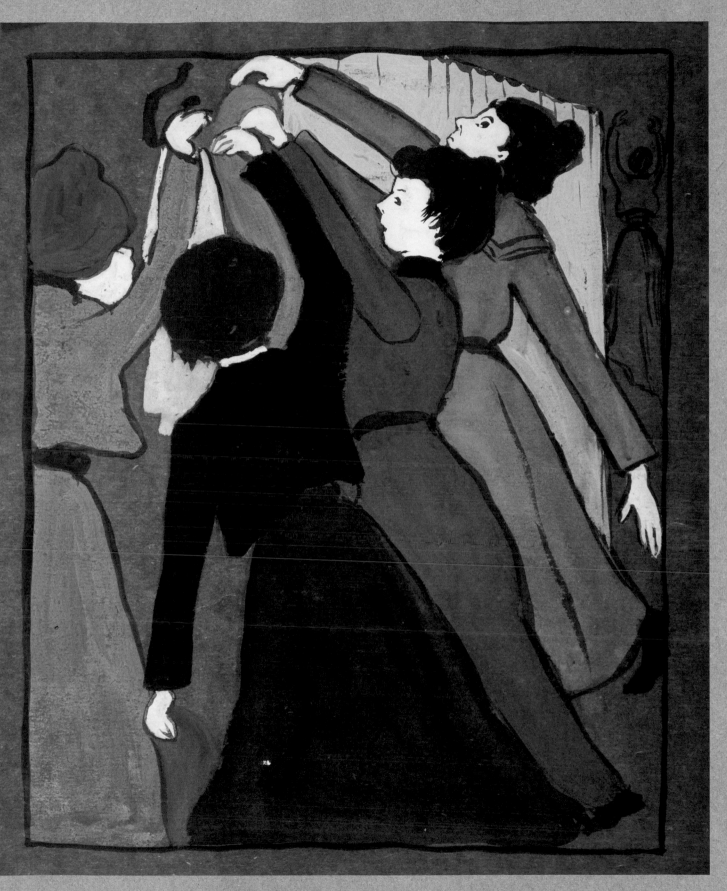

When you are ill in a cubicle
 The others are very kind,
They shake up your pillows and bring up your food,
 And to walk on their tiptoes they mind;
The iron they heat to put at your feet,
 Your head in cologne is tied up:
They lend you good books and give you kind looks,
 And such terrible physic to sup.

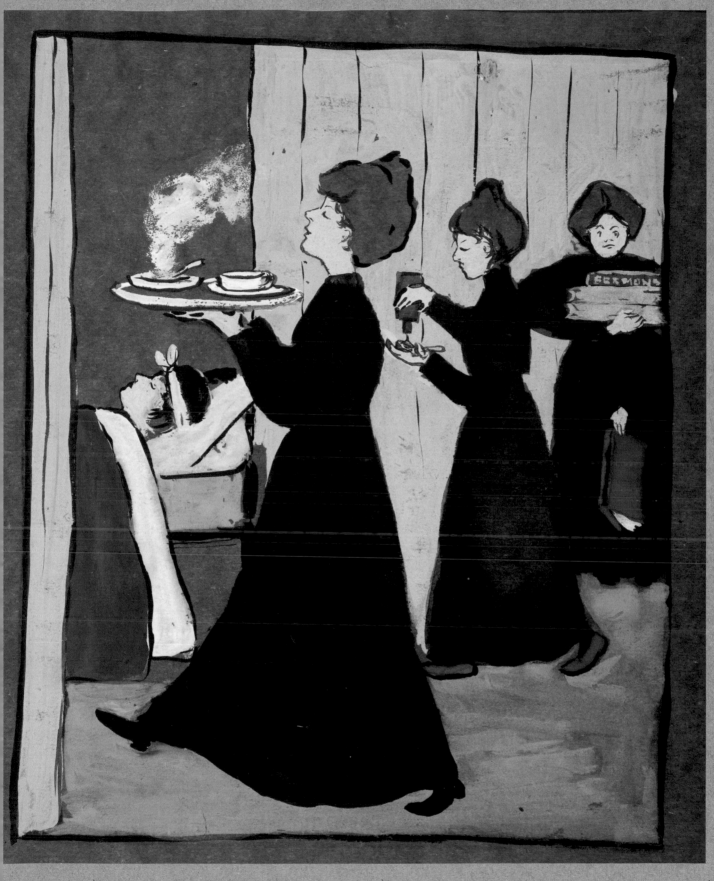

Rubbety, scrubbety, scrubbety rub,

 What in the world is all the hubbub?

'Tis Saturday night and our boots are being polished,

 We scrape and we rub till all dirt is abolished;

Each shine saves a penny,

 Though it takes a great many

Of the pennies to make up a pound;

 And it's exercise too, and warms you right through,

Making sleep the more healthful and sound.

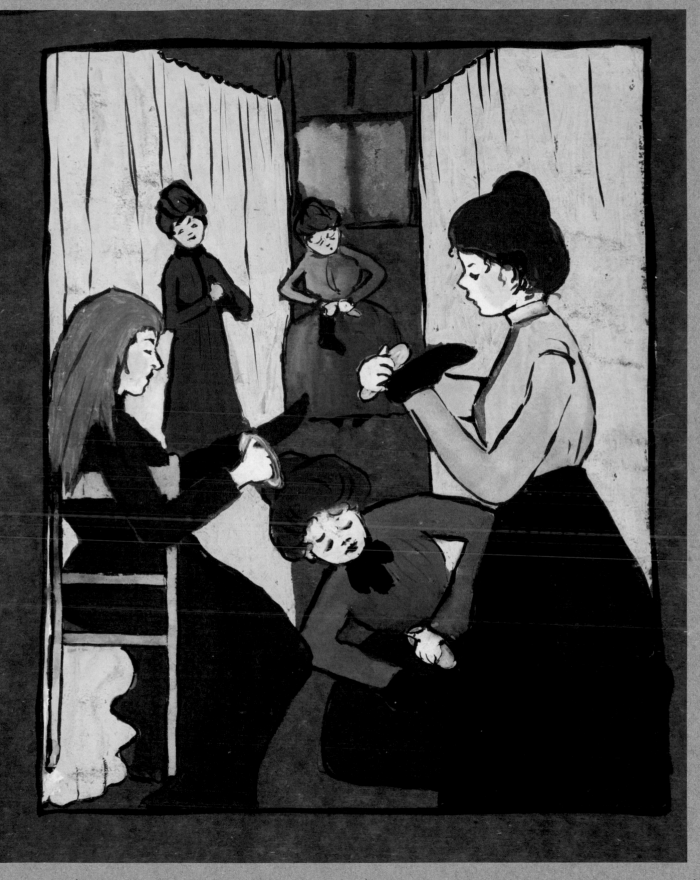

Oh! washing's so dear in London Town —
 But soap is a penny a bar,
And our laces are few and precious,
 And afraid of the laundress we are;
For they tear them and spot them and lose them,
 And this on our feelings doth jar,
So at times we have washing parties,
 And the iron is in great demand:
Though we like it not when 'tis over-hot,
 Burning our lace and hand.

Now she who doth talk in her sleep

 Had best from a cubicle keep,

For they wake up next morn feeling quite sore,

 And strewn all around on the bed and the floor

Are boots and pillows and bottles and shoes,

 And all the small things that a lady doth use;

And all in a chorus her neighbours do shout -

 " To-night if you talk we will have you put out!

" Now bring us our things, and take warning, we pray,

 " Or we'll get Mrs. Dodd to send you away:

" Who can sleep when a body is talking all night?

 " It is not at all fair and its not at all right."

Now one of our number possessed
 A wonderful parrakeet,
Which she thought in the front of her toque
 Would look too utterly sweet.
And then our opinion was asked
 Full sixty times in the day,
As to whether its glassy stare should be front,
 Or looking the other way?
On us all it was frequently tried,
 And just as it quite was complete
" Her Most Gracious Majesty " died,
 Order - Mourning - farewell parrakeet!
With a very long face and a very bad grace
 Fraulein's mourning at last was complete -
If the truth must be known, I fear I must own
 She mourned for the green parrakeet.

Someone goes out to supper

 Every Sunday night,

And does'nt return till after

 The hour for electric light.

She steals up the stair so quietly,

 And softly opens the door:

But a voice from the left

 And a voice from the right

Break forth through the silence and calm of the night-

 " Why could'nt you get home before?

" Your taste for late hours we deplore,

 " Our sleep you have broken,

" Or we would'nt have spoken."

Someone lent me a sewing-machine,

 And extremely busy it is I have been,

I have made a great pile of wonderful things,

 And they all are complete but the buttons and
 strings,

A new frock of blue and a lovely blouse too;

 You can't sew in small quarters - let those who
 will say-

I only repeat "where's a will there's a way!"

 And just as I finish old Kindal comes in,

With a ready-made suit and a ready-made grin -

 " Look, Carr, I bought this and it fits like a
 glove,

" It's so smart and so neat, and the blue that I love:

 " I am a stock figure, slight and graceful, you see,

And everything nice and genteel doth fit me,

 " While you, little Carr, being so chubby and fat,

" Must crouch on the floor doing the job you are at! "

 I sigh for a figure, I sigh for a purse -

But then, after all, my lot might be worse:

 I have ten nimble fingers and nine nimble toes,

And for all Kindal's figure -

 She's got a red nose!

The world is sad, and parting days must come:

 The room is filled with boxes -

The boxes packed for home.

 The fat ones sit upon them,

The thin ones turn the key:

 And some are stuffed so very full -

The sitters number three.

And woe betide the one that's left

 Not only of her friends bereft:

What e'er the others cannot pack

 They leave with her till they come back;

Beneath her bed is piled with things,

 And heavy on them bump the springs,

And when the maid comes up to sweep

 She scolds enough to make one weep

For having such an awful litter,

 And all the new girls start to titter.

She has to kneel two boxes high

 Before the glass to fix her tie;

And when the water-jugs upset

 The bags and boxes all get wet:

" Oh girls, come back! " she sadly says,

 " - I do not like the holidays! "

Some go and come no more,
 And some return again,
And plead with Mrs. Dodd to have
 The same old cube, in vain.
Someone has bagged your corner -
 You're sent to Number five,
Where candles light you to your bed,
 And mice run round alive!

Oh! was'nt it just too splendid
 When the Christmas holidays ended?
We came back to our corners
 Like little Jack Horners,
With such pies and such shortbread and cake;
 We sat on our boxes
As spry as young foxes,
 Nor dreamt it would keep us awake;
Pizzard made all the tea -
 We were nice as could be,
For dear old Christmas' sake.

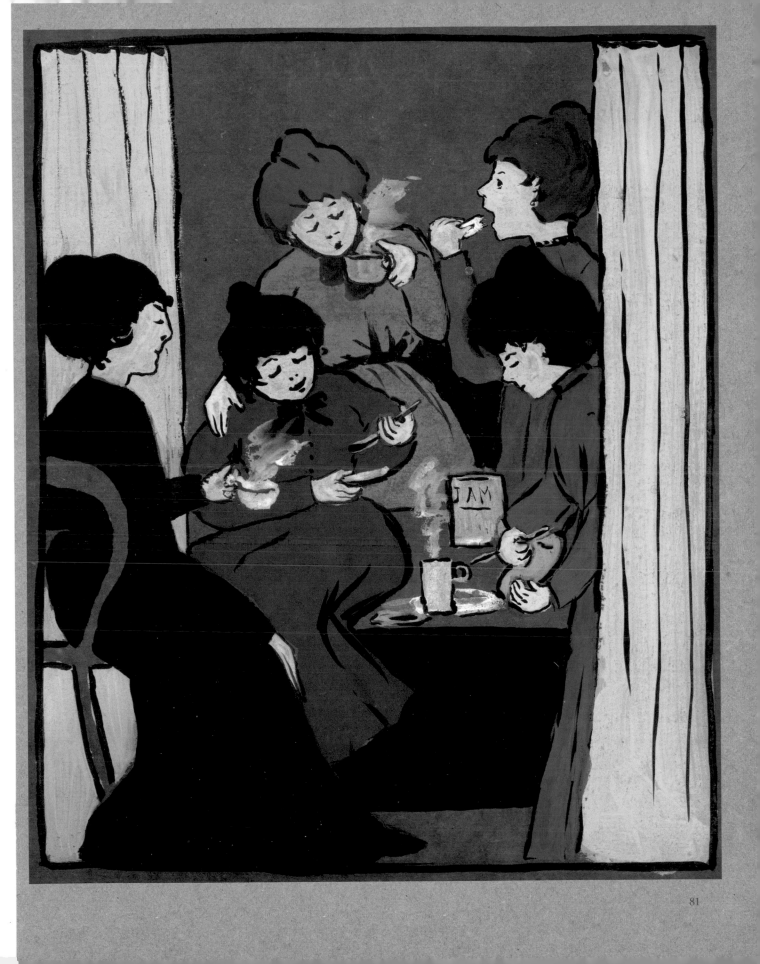

Kendal & I
Emily Carr,
gouache on paper,
1901;
private collection.

At six o'clock from sleep I wake
 By Kendal who my pillows shake,
Will you get up you lazy Carr?
 The sun o'er chimney-pots afar
Is rising and tis deep transgression
 To sleep and miss todays procession
Oh, slowly out of bed we rise
 With woeful, weary, sleepy eyes,
Tis half-way dark and chilly too
 And Kendals nose is red and blue.

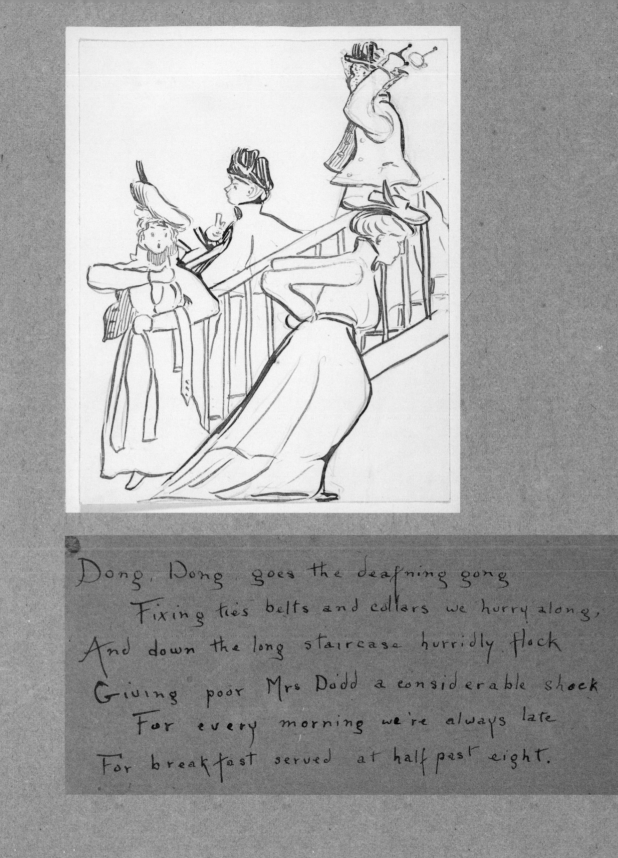

Dong, Dong, goes the deafning gong
 Fixing ties belts and collars we hurry along,
And down the long staircase hurridly flock
 Giving poor Mrs Dodd a considerable shock
 For every morning we're always late
For breakfast served at half past eight.

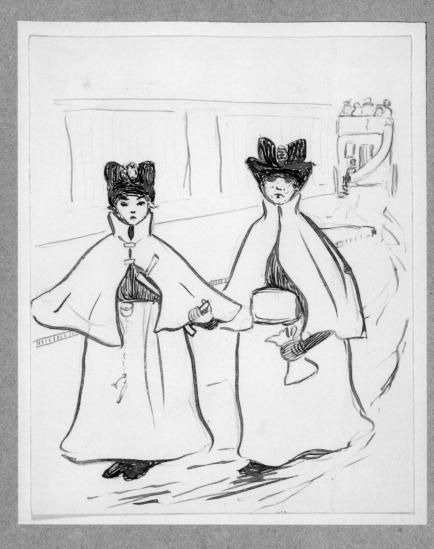

The bussman cast us off the buss
 Because we had not change with
Quoth Kendal, "Carr you are a fool
 To take with you that stupid stool
I've got a bag of Caramels,
 To eat when not observed by swells."

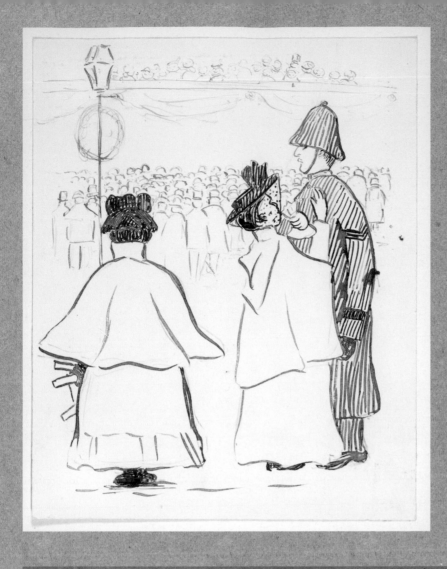

Saith Kendal, "Wont you Bobbey please
 Shew ws a spot where we can sqweeze"?
I stood behind and hid my stool,
 Because you know it was the rule,
No chairs or stools should be allowed,
 To persons standing in the croud,

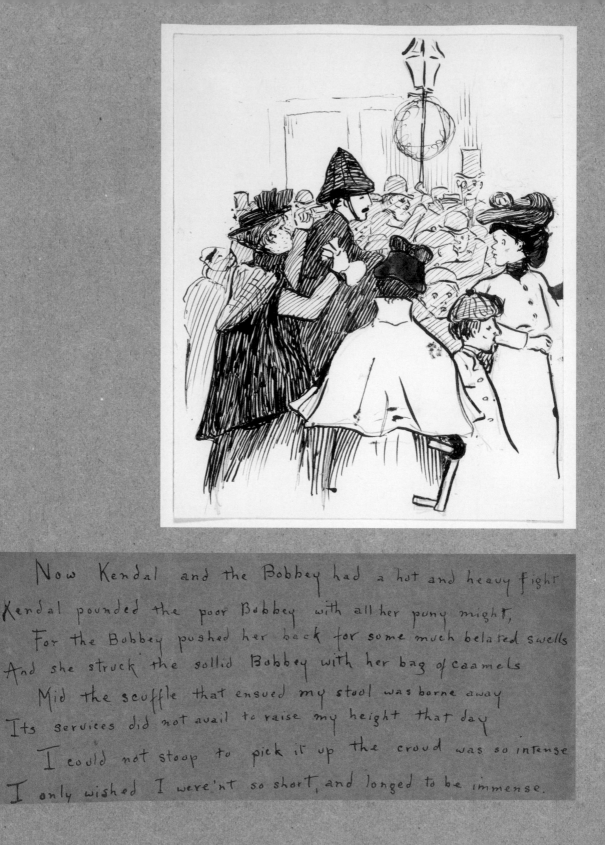

Now Kendal and the Bobbey had a hot and heavy fight
Kendal pounded the poor Bobbey with all her puny might,
 For the Bobbey pushed her back for some much belated swells
And she struck the sollid Bobbey with her bag of caamels
 Mid the scuffle that ensued my stool was borne away
Its services did not avail to raise my height that day
 I could not stoop to pick it up the croud was so intense
I only wished I were'nt so short, and longed to be immense.

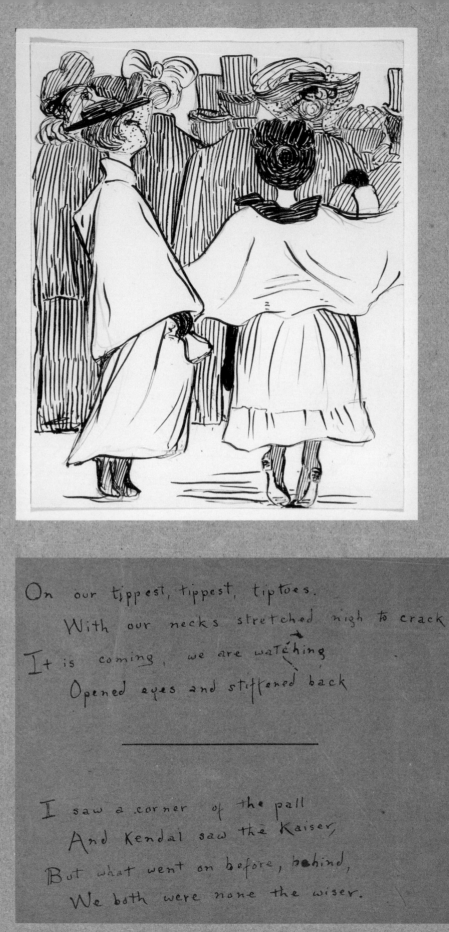

On our tippest, tippest, tiptoes.
 With our necks stretched nigh to crack,
It is coming, we are watching
 Opened eyes and stiffened back

———————————

I saw a corner of the pall
 And Kendal saw the Kaiser,
But what went on before, behind,
 We both were none the wiser.

The next few days were very bad
 Both for Kendal and for me
I lay in bed, with an aching head
 She wearily brought me tea,
And we talke'd it over gravely
 All the squeezing and the pain,
And we said, mid a croud in London,
 We would never go again.

Miss Livingstone you remember she was in Victoria for a while."[78]

The evidence of this trip has only recently surfaced and it puts to rest earlier conclusions that Carr was unaware or unaffected by modern art trends, that she had no curiosity to connect with current as opposed to traditional techniques maintained at the Westminster School of Art, which by the time Carr arrived, had lost its avant-garde edge. Carr wrote enthusiastically just days after her return from Paris, "the picture galleries were my great delight, they are delightful & it is such a pretty city too. I went to the Louvre every day; it was delightful to see the very pictures you had heard of & dreamt of half your life. I wondered if I'd wake up and find it was a dream."

Upon her return to England, Carr did not go to London for more studies but instead travelled by train 26 kilometres northwest of London to Bushey, a village where, in 1885, Herbert Herkomer had established an art school. "Bushey was a good deal talked of as an art colony in the country. The Herchomer school was there"[79] and she knew of it by reputation, probably discussed at her school, for it was progressive in its time. Herkomer claimed that "special features included a rural setting and seclusions from the seductions of city life,"[80] which would

have attracted Carr, but more particularly, Herkomer's philosophy rejected drawing – copying – from antique casts, because he fervently disagreed with the practice. Insisting students study the antique before progressing to the live model was the bane of Carr's art school experiences, a stage difficult for female students to break through. Herkomer advertised "life classes for women students and the encouragement of individual styles"[81], certainly an opportunity Carr needed to explore.

Carr wrote as though she arrived in Bushey without making any specific arrangements in advance, not even to contact the school. She quizzed locals for a recommendation, for she found there were other teachers, not just Herkomer, in the town.

When I left the train I rejoiced to see the open fields. "Which is the way to Bushey?" I asked the news agent.

His "Turn round by street 'ere Pub and keep a-goin'" was really a very direct answer.

I kept a-goin' a very long time the road meandered like a dream but it ended in the settlement....

Bushey is fully of studios & students besides having the Herchomer school. On enquiry I found that if I wanted theatricals dances & good times you went to the school, but if you were out

78 Emily Carr to Mary Cridge, 7 May 1901 (this and the next quotation). City of Victoria Archives. The 12 days in Paris would either be before March 31, when she was enumerated in the England census, or after Easter Monday, April 6. She would have gone to church in England for Easter holy days, timing her trip when the public galleries were open, not closed as they would be over Easter. It's impossible to know if she was in Paris before March 31 and, if so, whether she took in the Van Gogh exhibition.

79 Carr n.d.

80 Longman 1999, p. 3.

81 Setford 1983.

for hard work you went to Mr Whiteley's studio. I wanted work.[82]

Carr claimed that she decided against the Herkomer School in favour of tutelage under a different art master, ex-Herkomer student John W. Whiteley (1859–1936) because of local advice.[83] But another factor may have been her age, for it was Herkomer's policy to only admit unmarried women under the age of 28.[84] Carr was 29 in the spring of 1901, and though by all accounts youthful in appearance, she might have been uncomfortable lying about her age. It also may have been that by 1901 the Herkomer School and Herkomer himself was not the only game in town. Although the school did not close until 1904, several former students had already established themselves as teachers.

Carr's practice of conflating chronology in favour of a good story makes it difficult to separate her experiences at Bushey in 1901 from those in 1902. Biographers have previously assumed she was in Bushey only in 1902, but the May 1901 letter quoted earlier documents that year as the first visit. It also holds a detailed description of working *en plein air*, and her unpublished manuscript includes episodes not in *Growing Pains*. Together these sources provide rich detail and are clues to enable further research concerning the settings and the villagers she describes. Searching local archives in Bushey also provides further strands. For instance, a single tantalizing reference in the 1901 diary of a local resident artist opens up new possibilities that in this first year in Bushey, Carr also took lessons from Lucy Kemp-Welsh, a long-time Herkomer student, who specialized in animal subjects and tutored privately. Kemp-Welsh would later, after Herkomer's closed its doors in 1904, establish her own school. The diarist recorded that on June 13, 1901, she met "a Canadian girl, a pupil of Miss Kemp-Welsh, who was drawing the cat" at her teacher's house in Bushey.[85] I am unaware of another female Canadian art student in Bushey in 1901.

Whiteley's studio, #9 Meadows Studio, was in one of two large buildings, each divided into studios situated some 100 metres "away from the Herkomer Art School on a separated plot of land", presumably a meadow.[86]

The long unpainted shed-like building sat in a field. These were six studios with a veritable tunnel of draught from end to end of the building containing all their doors. Mr Whiteley's was No. 9. Mr Whiteley was very shy, he took about 16 students and used as few words as possible for teaching and none otherwise.[87]

Whiteley at the time was known principally as a figurative artist, although his classes included landscape. In either case, he emphasized outdoor work in oils, watercolours and pencil. And for

82 This extract from the unpublished "Growing Pains" manuscript (Carr n.d.) is a little different than the published *Growing Pains*.

83 Stated in both *Growing Pains* and the unpublished manuscript.

84 Longman 1999, p. 5.

85 Transcribed reference to entry for 13 June 1901 in diary of a Miss Godsall, summary notes and transcription by Grant Longman, on file, Bushey Museum, Hertfordshire, UK.

86 Grant Longman to Edythe Hembroff-Schleicher, 24 April 1979. MS-2792, BC Archives.

87 Carr n.d.

Carr, being outdoors was a priority. "After London the country is at its sweetest & though the weather is a little uncertain it is charming."[88] Whiteley himself lived at 168 Rudolph Terrace, with his wife and two young children. He was a Yorkshire man age 41, who had come to Bushey prior to his marriage. Carr made connection with Whiteley and lessons began. Carr wrote riotous stories for *Growing Pains* about her lessons under John Whiteley and of her fellow students. But the unpublished writings together with census information offer more detail about her experiences and the people she met both in the classroom and the village. She reveals a comfortable rapport with Whiteley.

Today there was a hail storm while I was having my lesson but the master grabbed the easel & study & I grabbed the stool & pallet & we got into a ditch under the hedge & discussed art till it stopped which was not very long. The sun is most provoking it comes out when not wanted & hides when desired. I keep two studies going one dull & one shining and whenever the sun shifts I likewise may be seen flying over the stile between the two it is quite exciting.

Weather permitting, figure studies were also outdoors, and outside of classes, the students arranged for local villagers to model for them on Saturdays (Carr would later do the same in St Ives). Only a few of these pencil drawings have survived in one of Carr's sketchbooks. Although Whiteley is noted as a watercolourist, Carr used oil paints in the fields outside the village. She wrote about the hazards of weather, overly curious children and farm animals.

Yesterday by great ill luck I pitched my easel in a children's play ground as they were all in school I did not know.[89] I was serenely in the middle of my study when out they all swarmed & I was fairly besieged & I never saw worse mannered ones. I stood it as long as I could & then I turned about "look here you have got to go you all sniff". They retired behind the hedge & those who had not pocket handkerchiefs polished up on their coat sleeves & then they returned. This time accompanied by all the babies who had to be minded by the elder ones & kept tumbling into the paint finally when they had kicked over the easel & spilt the turpentine I threatened to go for the Police & they got scarcer though they insisted on playing ball across me & kept up a dreadful din with an old tambourine & two oil cans just the other side of the hedge. Today I was more lucky I kept away from the schools & was only accosted by a boy with a perambulator full of weezened up twins.[90]

Soon she was not the newest student and able to provide advice to a newcomer.

There was the usual discomfort of strangers, at first nobody told you anything and giggled when you fell through ignorance. After a

88 Emily Carr to Mary Cridge, 7 May 1901 (this and the next quotation). City of Victoria Archives.
89 Two schools in Bushey are candidates for the location of Carr's sketching spot. The Merry Hill School was just down the road from her lodgings and not far from the Meadow Studios. The Bushey Infants School at The Rutts on Bushey Heath 1885 was a little further distant. She would certainly have walked to her spots from the Meadows Studios. See Hands and Woodley 2002.
90 Emily Carr to Mary Cridge, 7 May 1901. City of Victoria Archives.

week of feeling like a fish in a desert I encountered a forlorn boy in the corridor. "Please," he said like a lost pup. "Which is Whiteley's studio?"

"No. 9."

"Please," he said again, "when will he be there?"

"Not till the afternoon."

"I'm a new student." He might have been an oldster.

"I'm a new one too. You want to know things?"

I told him all I had found out by my own experience. Where you went to buy material, how you primed canvas. How you got your easel & drew for places. He was very grateful we were soon good friends. The boys were nice to him and to me. We left the girls quite alone.[91]

Carr says that because she arrived in April and missed the beginning of term, lodgings conveniently close in the village were taken so she had to search on the outskirts "to a row of working men's houses."[92] The return address on the letter she wrote from Bushey that year says "Merry Hill", which is at the far end of High Street, up the hill, beyond Herkomer's School and the Meadow Studios. She lodged with a newlywed couple expecting their first child. She fictionalizes them as "David and Jane Martin".[93]

The following passages from her unpublished manuscript illuminate how the arrangement worked. Carr occupied the front of the house, her landlords the back: a novel but practical means of renting out the parts of the cottage most desirable to lodgers. It was, however, not without some awkwardness.

Mrs Martin had the centre cottage. She rented the front lower & the upper back, keeping upstairs front & downstairs back for herself. The Martins were dreadfully lovey dovey & this was their first baby. Their wedding gifts occupied my parlour; a family bible on which was written on front page. "Full & complete list of wedding presents received by John & Jane Martin on the occasion of their first marriage." There were vases, bed spreads, spoons, crochet mats candlesticks tablecloths ... the bible itself was the gift of her former employer.

"You see Miss," said John. "I was seven years cortin' 'er."

"A long time Mr Martin."

"I only seen her onet'a year for five."

"Y'se Miss she were cook an me were gardener at same place. I left an she stayed an I could only get onet a year till we'd saved to marry on. 'Er Mistress give us the bible & with your permission we will point to the articles."

So they came into my parlour & "pointed".[94]

Carr got to know the neighbours and experience the dynamics between the residents of the row of cottages whose back yards connected.

Behind each cottage was a tiny patch of earth separated by picket fences where a few lettuces radishes & onions grew the little gardens were assiduously tended

91 Carr n.d.

92 Carr 2005, p. 218.

93 Census and directory searches do not find Martin, but they do find a John and Lisette West (née Martin) at Ivy Cottage on Merry Hill Road. The Wests, both age 22, married earlier in 1901.

94 Carr n.d.

& very neat. Up & down the row of gardens you heard lots of gossip flipped over the fence. The policeman's wife, with four under five[95] already, produced a sister while I lived in the row. The four under five where stowed up & down the row. Before the babe was two weeks old Mrs Police tapped on my door & asked permission to bring the babe through my sitting room to show Mrs Martin as other wise she would have to lug 'em 6 doors up or six doors back to get round to Mrs Martin's back door "ay e's a heavy lunk of a lad." said the new mother.

Next door to us lived a prodigious family, the three elder ones were half wits. Mrs Martin said it was "beer done it." The younger three seemed very smart so perhaps the beery lady had turned over a new leaf. The boy next the youngest & I were great chums. He would rush home from school & searching the fields for me so as to carry my sketch gear home. Every Saturday his big brother Tim bought a rosebud for his button hole & went to see his girl Sunday. Monday the rosebud was the property of the two half wit girls who quarrelled over it till Ma took & threw it into the ash bin. Tuesday the little boy rescued it pulled off the dusty outer leaves & gave it to me with a sly grin. I wore it to school.

The father was a cow man who tramped five miles night & morning to his work. The looney son at this heels. My small boy's ambition was to be a cow man like Father.[96]

In this lodging, Carr was embedded for the first time in a working-class neighbourhood. This was different from walking quickly through or alongside tenement houses on a shortcut to art classes in London, or visiting the inner city slums for church work. This was residency, and a decidedly different experience for her. It may have reinforced the opportunities for friendship across the divide of class and made her a little less rigid in her thinking. When Carr wrote describing her new neighbourhood and landlords in Bushey, she did so from her upper-middle-class perspective and comments on the Martins and their neighbours in the same way she described the working-class school children with their runny noses – catty yet infused with a sense of kindness. Beyond the paternalistic stance, Carr seems genuinely fond of the people she described. Sometime later in the year, or even the year following, she wrote to tell her landlady that she would be travelling by train through Bushey and wanted to say hello, if even just through the train windows as it stopped in the small station. This was an act of friendship, motivated by a desire to keep in touch and perhaps curiosity to see how the couple were keeping after the birth of their child.

Later when I was passing through Bushey on my way to pay a visit to Mrs Mortimer who was summering nearby. Mrs Martin brought her baby to the train to see me there was only a few minutes to talk. I shouted above the Pouf Pouf of the starting engines "whats her

95 The 1901 census lists the Furness family on Herkomer Road as a policeman, his wife and four children under five years of age.

96 Carr n.d

name?" "Mary Annnnnnne Missus." and the layette I had watched being made and was now full of babe was gently waved in the air.[97]

Carr conflated many of her adventures when writing stories for publication so that she could emphasize themes. This nonlinear recollection of events has created difficulties for scholars wishing to establish chronological certainty. Carr's experiences in Bushey have proved difficult to follow for this reason. What now seems certain is that she was there on three separate occasions: first, as described, in the spring of 1901, then again the following spring and finally in early 1904. She was drawn to Bushey at first because of its proximity to London and by the reputation of the Herkomer School, but returned twice more because of the setting and the inspirational teachers. The following quote illustrates how she conflated her visits to emphasize the therapeutic effects of the countryside. But Carr's first visit to Bushey ended with sister Alice's arrival in London, the 1902 visit occurred after St Ives (she was not escaping London, as other biographers have stated) and the 1904 visit came after her release from the sanatorium (not after an extensive time in London). In all cases she was in Bushey during the spring.

The fields & little woods around Bushey were beautiful. I was there through a Spring. All night the nightingales sang and in day time the woods bubbled with birds. The new foliage the lush grass the Cucoos and blue bells & primroses and anemone were just intoxicating. I used to sing & sing & sing in the woods and the horribles of London faded from my mind but by & bye even the sweet lovelinous of Bushey with its tinkling brooks & chortling birds palled. I wanted the roaring rivers the dense forests the fine swooping birds with keen searching eyes. I had been born of English parents with English Ideals, but I was born in Canada. What I was [was] stronger than what I came from. I went back to London.[98]

An impression of John Whiteley published in an article in 1905 a few years after Carr's time in Bushey is helpful in placing him as an effective teacher. "Students work under the special direction of Mr John W. Whiteley, himself a Bushey artist of some repute, and possessed of that special and indescribable knack of imparting a necessary word of suggestion or advice at just the right moment."[99]

Carr had great respect for Whiteley. She called him "the most serious of Masters" and the students working under him "were the hardest diggers I ever saw…. One thing Mr Whiteley told me that I never forgot, he said, 'Remember the going & coming among the trees don't paint flat walls.' Perhaps that is where my first notice of tree movement was born." [100] Whiteley and his wife feature flatteringly in *Growing Pains*, his importance to her artistic development clearly delineated. Carr treasured and maintained relationships with the teachers she respected and felt a

97 Carr n.d.
98 Carr n.d.
99 Crozier 1905.
100 Carr n.d.

connection to, those who made a difference to her and impressed her – Whiteley was one of those.

In late June 1901 Emily returned to London and to Mrs Dodd's boarding house. There she awaited the arrival of her favourite sister, Alice, who had left Victoria on May 28 for a summer of adventures with Emily. Bushey had been intended as a breather, an opportunity to reconnect with the countryside and to work hard, as she knew Alice's intention would be to visit London and its "national astonishments" – so Emily prepared for time away from her art. She was excited about Alice's arrival. Alice had written to her faithfully twice each week over the past 18 months, and through their correspondence the sisters had made plans. Emily knew that Alice needed a break from teaching in her private school. "She works so hard," Carr confided, "far too hard, and does not seem to have been up to the mark lately but I am shure this [vacation] will set her up for 10 years."[101] In *Growing Pains* Emily indicates that she took lodgings for Alice right in the heart of the city. Besides exploring the city and acquainting Alice with the Reddens and others, Emily probably also took Alice to Scotland to visit with the Anderson family with whom Emily had stayed the previous summer and Christmas.

Alice's visit was a mixed success. By all accounts their reunion was emotional. "She came in the evening. We talked all through that night."[102] But Emily appears to have taken offence at Alice's lack of interest in seeing her art or learning about her studies. By the beginning of August, the sisters travelled southwest by rail heading for Cornwall. Although Carr doesn't directly mention it in *Growing Pains*, they may also have stopped in Devon to see Barnstaple, where their parents and elder sisters lived just prior to their move to Vancouver Island. Carr writes that she was disappointed in the landscape of Devon, having heard her parents years ago exclaim over its loveliness. She found it "small and pinched."[103] Their destination was farther south, the village of St Ives in Cornwall, for she was following advice to study outdoors on the coast, at a place renowned by artists for its unique light and for the quality of art instruction there. Changing trains in St Erth, they skirted salt flats and then followed a breathtaking coastline. Fine white sandy beaches interfaced with blue sky. From the train station above Porthminster beach, a porter hand-carted their luggage along the winding cobbled streets to the Temperance Hotel on Tregenna Place in the old part of town. Emily felt guilty registering at an establishment so overtly tea-total, because her luggage included four bottles of pink wine from Mrs Crompton-Roberts. From there the sisters got oriented, Emily to investigate art classes and Alice to find longer-term accommodation and to explore the town. In *Growing Pains* Carr gives no indication that Alice accompanied her to Cornwall. She writes as if she is alone, yet we know Alice was there because the local St Ives newspaper records "Miss Alice Carr" at "the Draycott, one of Mrs

101 Emily Carr to Mary Cridge, 7 May 1901. City of Victoria Archives.
102 Carr 2005, p. 174.
103 Carr 2005, p. 204.

Treleaven's hillside cottages" from August 10 to mid September.[104]

The chronology of events, motivating factors and rationale for Carr's decision to try St Ives are confused if we read *Growing Pains* as a linear narrative and forget that it is a series of vignettes loosely based on her life experiences and not at all in strict order. Knowing that Emily was in Bushey in the spring of 1901 prior to St Ives provides strong possibility that she was directed to St Ives by Bushey students or her teacher John Whiteley – not merely by the suggestion from Mildred Crompton-Roberts, as she indicates in *Growing Pains*. The artists' colony was well established and reputable, and provided an English alternative to French studies. Carr had already seen at least one painting by an artist there – Moffat Linder, whose *St Ives' Beach* hung in the Crompton-Roberts drawing room – and she had most likely attended the Royal Academy shows where other St Ives-based artists works were hung. Her decision on St Ives was more informed than appears in her writing, and, I would suggest, more organized. In *Growing Pains* Carr repeats the same scenario as she noted for Bushey: that she had made no prior arrangements, that she relied on local knowledge for advice about who best to study under. "Did I want *work* or did I want studio tea parties? – Work? – Then go to Julius Olssen's studio; he worked you to the last gasp."[105] These "stories" are too similar. Carr was on a budget, was mindful of her time away from home and would not be so uninformed. After all, Whiteley would

have known St Ives art master Algernon Talmage during the years Talmage spent in Bushey, and also known of Julius Olsson, with whom Talmage shared teaching duties in St Ives, by his reputation and his art, for he was established and well known. Certainly these connections – the social and professional ties between artists in Bushey and St Ives – would have enabled Carr to be informed. We do her a disservice in believing that she was anything less than a serious planner.

Carr had decided to take a break from the Westminster School of Art before her sister arrived. Discussions with instructors or fellow students there probably provided inspiration for choosing Bushey. While in Bushey, perhaps further talks suggested another place to pursue studies, at the artist colony in St Ives. It is an interesting sequence and connections: Westminster, Bushey, St Ives. Art teachers at Westminster had spent time in Bushey and those in Bushey had connections to St Ives. The connections between Bushey and St Ives art schools are clearly visible in the larger context of artists and art instruction in the early 20th century, with masters and students moving from one to the other. In the space of 18 months Emily moved from one circle to the next and then back again. At St Ives, former Herkomer student Algernon Talmage received as a student Emily Carr, who had learned from Talmage's previous colleague John Whiteley in Bushey.

Carr evidently remained for some months in St Ives at the Temperance Hotel,

104 *St Ives Weekly Summary* newspaper, "Draycott Cottages Number 4, Mrs Treleaven, Miss Alice Carr". Alice is listed there until September 14.

105 Carr 2005, p. 205.

which was run by the Hodge family. By Christmas she moved to rooms in the house of locals Charles and Kate Curnow on the harbour side of St Andrews Street, only a few doors down from St Ia, the parish church. The Curnows and their two daughters, "who would never see forty again",[106] were kind to her.

> I found living quarters next to the churchyard. My host was a maker of antiques; he specialized in battering up and defacing old ship's figure-heads and grandfather clocks. Six grandfathers higgley-piggledyed their ticks in my sitting-room. When they all struck high-count hours simultaneously your hands flew to your ears, and your head flew out the window.[107]

Carr's bedroom at the Curnows' was upstairs and her sitting room on the main floor.

> My window opened directly onto the cobblestoned street with no mediating sidewalk. Heavy shoes striking cobblestones clattered, clattered day and night. Student heads, wrapped in student grins, thrust themselves through my window announcing, "We are about to call!"

In *Growing Pains* Carr gives vivid accounts of these landlords (and their Christmas Day preparations), how the women carried hot water upstairs to the bathing tub for her, and descriptions of the interior spaces of the house itself. It sat in a vulnerable position backing on the sea wall, which meant that winter storms washed right over her windows, engulfing the building.

> When storms came the whole St Ives Bay attacked my room with fury and with power. The house was built partly on the sea-wall, and waves beat in thuds that trembled it. The windows, of heavy bottle-glass stoutly braced, were dimmed with mazed green lights. I was under the sea. Sea poured over my roof, my windows were translucent, pouring green, which thinned, drew back receding in a boil of foam, leaving me amazed that the house could still be grounded … we were surrounded by water. Privies, perched on the sea wall, jaunted gaily off into the bay….[108]

Carr probably began art studies in August, one of several students working under the renowned marine painter Julius Olsson (1864–1942) and landscape painter Algernon Talmage (1871–1934), who together ran the Cornish School of Landscape and Sea Painting.[109] The students worked in oils outside in all but the worst weather, at which time they retreated to the school's Harbour Studio above the beach and worked on figure studies. The two masters were different in outlook and temperament as well as in their own personal backgrounds and art training. Olsson was largely self-taught, while Talmage hailed from a series of art schools. Together they offered the students

106 As usual, Carr exaggerated. The daughters were enumerated in 1901 as 32 and 33 years of age, only a couple of years older than Carr.
107 Carr 2005, p. 208 (this and the next quotation).
108 Carr 2005, p. 210.
109 Tovey 2008, p. 133.

a range of instruction and alternative methodology. They emphasized the effects of colour and tonal ranges, and the importance of light, of lighting itself within the painting to enliven flat landscapes of marshes or curving hills, to provide interest and richness in sea views. "Their teaching was so highly regarded that a number of Olsson's students considered that time at St Ives removed the need to study in France."[110] Perhaps Carr felt the same. Works created by students of Carr's day show modernist characteristics, the influence of Paris and a move away from the traditional British landscape style. Working at St Ives therefore immersed Carr in an artist colony linked more directly to Paris than London, whose artists exhibited regularly in Paris. Following just months after her own trip to Paris, Carr would have been able to converse with those around her about modern art trends and Paris itself. This time in St Ives was not escaping from tradition, but being pushed to see beyond the comfortable. It would have been stimulating.

She later wrote, "I fell on my work with tremendous zest." But Carr's experience was not a straightforward progression. Her previous training in San Francisco, London and Bushey had been to work under one master in each class. With a single instructor came a single focus and single perspective, making it possible to follow directions without fear of losing track. But in St Ives, with Olsson and Talmage sharing duties, she found it difficult to adjust. "Olsson & Talmage were both good teachers but quite opposite but

contradictory what one made you do the other made you undo."[111]

The routine of art classes in St Ives included long days beginning each morning at 8 AM. The students met at the Harbour Studio to receive critical comments from the teachers on their previous afternoon's work. If the weather was extremely inclement, the students sketched indoors in the studio using a still life or a hired model. Three times weekly, Talmage and Olsson alternated visits with the artists situated at their easels outdoors to comment on the work in progress. Carr notes that her landlady packed her lunch sandwiches, often fatty pork, to tide her over while the light held until the day's work ended. During Carr's time in St Ives, moonlit studies were in vogue, extending the artists' days into the night.

The emphasis on *en plein air* required adaption for the weather as it was always breezy. As summer moved into autumn and winter, days grew shorter and colder. It seems that most of Carr's cohort used easels with special-order heavy frames. Carr knew she would be incapable of carrying such a heavy item, so she made due with a rock encased in a paint rag as ballast for the easel. The expected painting sites were on the semicircular sands of the town harbour either looking out to the sea and to boats in the harbour, or over the sands looking toward the town or Smeaton's Pier with its hexagonal lighthouse. They also worked on Porthmeor Beach, a long broad expanse flanked by headlands on the opposite side of town, which faced northwest directly onto the Atlantic Ocean. Here also, they

110 Tovey 2004.
111 Carr n.d., and similar thoughts in Carr 2005, p. 208.

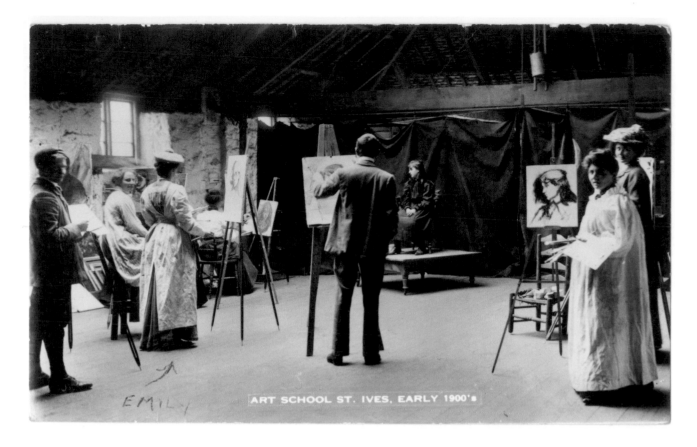

At work in the Harbour Studio, 1901–02. From the left, Will Ashton, Hilda Fearon, Emily Carr and other students. Herbert Lanyon photograph; I-68874.

came at night to sketch the moonrise. "We have been having some glorious moonrises here. This moon, everyone has been doing moonrises."[112]

Despite the word "landscape" in the school's title, Olsson's fascination with the ocean meant the focus was on marine subjects. During Carr's tenure there, the emphasis was on the experience of light and light sources on the subject matter. Students painted the ocean in bright sun and on cloudy days, working gradations in colour. Whitewashed buildings, the white Sloop Inn, white sails and boats, white sands. Bright sunshine and more subtle moonlight challenged the artists to capture

mood and create scenes of movement and interplay between boats, waves, horizon and sky. Although other artists working under different masters painted in the cobblestone streets capturing village life, Carr did as was expected of her group and worked from the beaches for as long as she was able.

Emily wrote about her lessons at St Ives and the frustrations of focusing on marine subjects when it was the landscape that called, but she was also coping with something entirely unexpected. She had decided on St Ives for the opportunity to work *en plein air*, to gain experience from an international cohort and to be

112 Arthur J.W. Burgess to Muriel Coldwell, 3 November 1901. Private collection.

Algernon Talmage (possibly)
visiting a student at work.
Emily Carr, graphite and ink on paper, 1901;
PDP05910.

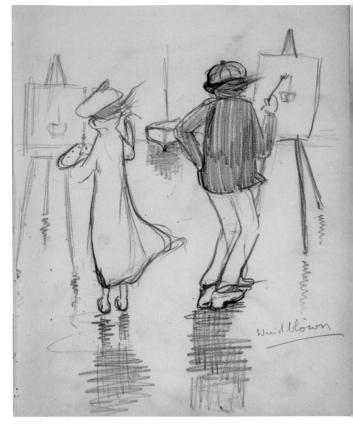

Windblown
Students Hilda Fearon and Noel Simmons
on the beach below the Harbour Studio.
Emily Carr, graphite on paper, 1901; PDP05909.

stimulated by current art ideas. In many ways it was an ideal situation for artistic inspiration. The long-established village of hard-working fishers was relatively isolated. The collapse of mining, shipbuilding and the pilchard fish stocks might have spelled death for the town, but in 1877 a branch rail line from St Erth connected St Ives to the network of British railway travel. St Ives invested in infrastructure and reinvented itself as a health resort, and later, after Carr's time, as a tourist destination – the "Cornish Riveria." Artists began to visit for extended periods, more visitors came for the summers and supported the local economy. The town welcomed increasing

numbers of artists into their midst as permanent residents. They came to escape the urban centres and in so doing created a lively and populous "art colony" which attracted international attention and whose economic input – rentals, subsistence and patronage – enabled the village to survive as fishing changed. It should have been a respite for Carr, with the fresh air and rural living, and an ideal setting in which to learn from important masters. But what she had not considered was the effect on her of the brilliant sunshine – the very light so prized by artists there.

It was the glare from the sands in the long sunny summer leading into

the autumn and the expectation that the students paint on the beach in what seemed to her as exposed and unmitigated brilliance that posed the problem for Carr: eyestrain and headaches. She longed for the shade and wished to focus on the town itself, the streets and the wooded areas away from the beaches. Residual discomfort from the operation on her toe the previous year meant she insisted on sitting on her stool to paint. It was a point of difference between master and student, but Carr kept firm. In *Growing Pains* she tells of the struggles she had with Julius Olsson in this regard, and it proved to be, in her remembrances, a defining aspect of her months in Cornwall. But she received important support from Talmage who, as a landscape painter himself, understood her need to retreat to the woods and patiently followed her, three days a week, climbing up the hill out of town to Tregenna Wood to give her critical appraisals. Like John Whiteley, Algernon Talmage provided her with advice that would inspire her for a lifetime.

The wind of St Ives was boisterous but the sun was glorious. I was going down hill in health. I had dreadful nervous billious headaches. All I could do was go to bed for a few days & groan and worry because I was missing my work. The strong dazzle of the shore tired me very much & I was always wrestling with Olsen about it. I think he delighted in coming up behind me in the soft sand and suddenly balling in my ear & making me jump & then a bad head would start. If I worked behind in the narrow little streets the wind tore through but the glare was less obvious.

Then I discovered Tregenna Wood, a delightful place up on the hill, dark & restful. Olsen went off to Sweden on his yacht for the Xmas vacation he stayed 3 weeks all that time I worked in Tregenna Wood very happily. Talmage was very kindly.

"Trot off to your woods. I'll come up and give you your lesson."

"Doesn't it take you a long way Mr Talmage?"

"I don't mind. You do your best work there and are happy."

Happy I was in the calm airy quiet….

J.O. was coming back & I said to Mr Talmage "I am very sorry I get so much more from your lessons than his. He will make me work in that horrible glare again – I hate old Olsen enormously!" "Any way he'll have to admit I've got on while he was away." I said boastfully. "You are ever so much the best teacher."

"Olsen is a genius," said Talmage. "I've had to grind for what I got so perhaps I can explain easier…. Look out there – remember the sunshine is in the shadows as well." I never forgot that "there is sunshine in the shadows."[113]

Carr seems to have mixed well with her fellow students in St Ives. She did not criticize them for standoffishness as she described Westminster or Bushey. "The St Ives students were a kindly lot – ready to give, ready to take, criticism." She records: "We numbered ten or more in the studio. Three Australian boys, a Frenchman, an ultra-Englishman, and an ultra-Englishwoman (swells rooming up on the hill), a cockney, the Irish girl, myself, and the nondescript old women

113 Carr n.d.

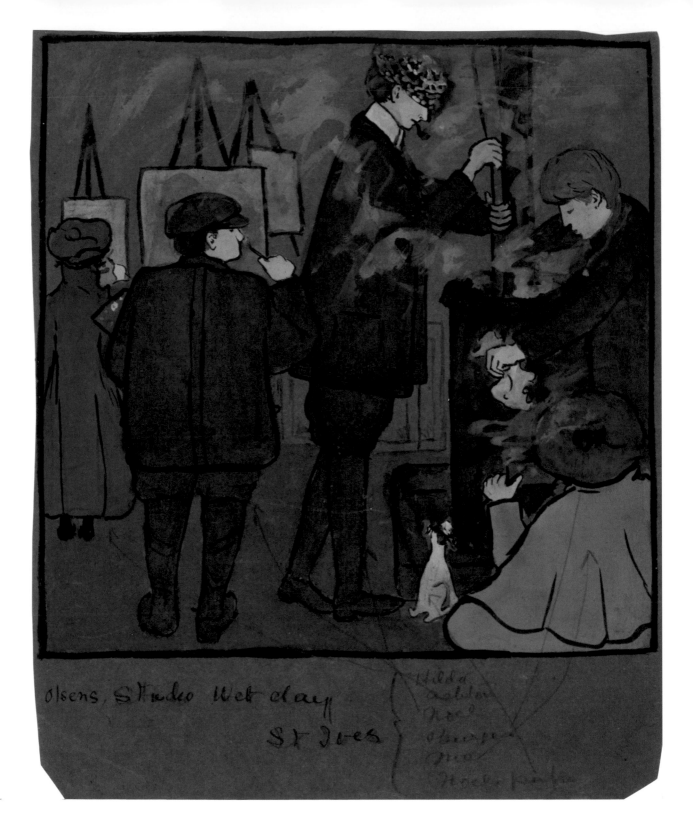

Olsson's Studio, Wet Day, St Ives
Left to right: Hilda Fearon, Will Ashton, Noel Simmons (and his puppy), Arthur Burgess and Emily Carr.
Emily Carr, gouache on paper, 1901–02; PDP09017.

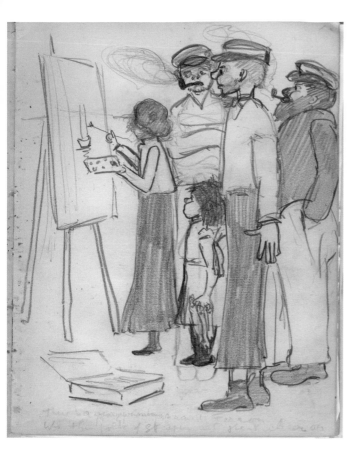

"There is a 'wummun' named Fearon
That the folk of St Ives set great cheer on."
Emily Carr, graphite on paper, 1901; PDP05893.

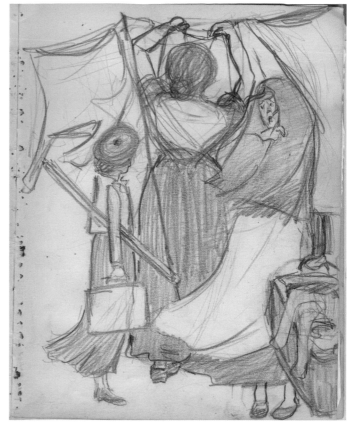

"The women tell her of such woes
As how the wind won't dry the clothes."
Emily Carr, graphite on paper, 1901; PDP05894.

who are found in most studios just killing time."[114] This enumeration is important and when correlated with the individual student names noted elsewhere in her writing, and it enables a reconstruction of her cohort and a sense of the group dynamics. Art historian David Tovey used Carr's descriptions and sketches, along with his extensive knowledge of the Cornish art scene, to identify almost all of Carr's classmates. The Australian boys were William Ashton (1881–1963), Arthur Burgess (1879–1959) and Richard Hayley Lever (1875–1958). All would have significant careers. The Irish girl was

Hilda Fearon (1878–1917), not Irish at all but from Banstead, Surrey. The ultra-Englishman was Sydney Noel Simmons (1880–1916), born in Addleston, Surrey, and not "ultra" at all – his father was a retired brewmaster. The ultra-Englishwoman was probably Marion Francis Horn, who had her own studio. One of the female "swells rooming up the hill" was identified by fellow classmate Burgess as Elsie Money from Hertfordshire. The Frenchman remains unidentified. The cockney, who Carr also called Albert, may have been Alfred Bentley, who drew a pen portrait of Carr that she brought home to Victoria.

114 Carr 2005, p. 207.

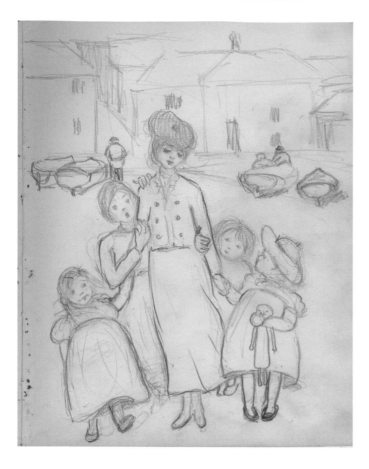

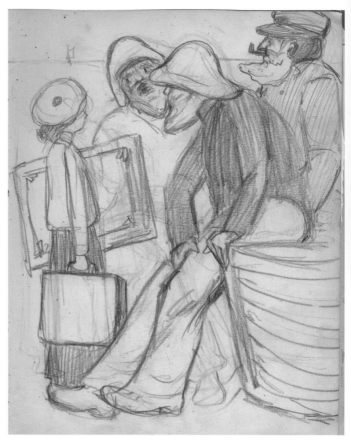

"As sticketh close the blight to rose
Close flock the kids we'er she goes."
Emily Carr, graphite on paper, 1901; PDP05895.

"The old men tell her how the fish
will not be caught as they could wish."
Emily Carr, graphite on paper, 1901; PDP05896.

The nondescript old women may include a Miss Read, referred to as "the Old Bird" in letters from Arthur Burgess.[115]

Carr's closest ally, Hilda Fearon, features in six pencil drawings and verse in Carr's St Ives sketchbook in the BC Archives holdings. The third daughter of a wine merchant, she was younger than Carr but had recently studied at the Slade School in London (and perhaps knew Theresa Wylde or Sophie Pemberton) and in Dresden, so she had the panache of the continental art scene. Fearon was one of several young women – mostly Slade students from London – who shared rented rooms in an establishment known locally as "The Cabin." Like Carr's own digs, "The Cabin" was in the old town, close to the harbour. If we interpret Carr's sketches, Fearon was lively, engaging and popular among the villagers. Carr's sketches show her slight figure carrying her enormous canvases, painting on the beach or sitting on her paint box conversing with the locals. It is probable that Carr created a short funny book featuring Fearon, as she had

115 Tovey 2008, pp. 127–34; Tovey 2009, pp. 240–59; Arthur Burgess to Muriel Coldwell, 3 November 1901. Private collection.

"And as for the lover's quarrel she hath a ready ear
Discordant couples seek advise and soon depart
with cheer."
Emily Carr, graphite on paper, 1901; PDP05897.

"And where is she [Hilda Fearon] at Midnight?
Why standing on the quay. Watching the boats with
nut brown sails tossing on the sea."
Emily Carr, graphite on paper, 1901; PDP05898.

in London earlier that year with Hannah Kendall; the sketches with their verse certainly suggest so.

Carr and Fearon hired models, fisher children, "to pose for us in the evenings, working by a coal-oil lamp in my sitting-room. The boy students jeered at our 'life class' but they dropped in to work with us off and on."[116] One of Carr's sketchbooks from St Ives survives, providing evidence – lacking for London – of the art she created at the time. It is filled with pencil studies of children and other villagers, who sat for her. Some of the images may also be of her art friends. Two images, one titled "Toothache and Patches" and the other with a guitar, may be self-portraits.[117] Another shows Carr's sitting room with her guitar and two wooden dolls posed on an upholstered chair in front of the fireplace.[118]

Carr got on well with Hilda Fearon, but despaired of one annoying trait: Hilda never seemed to have pocket money when it was needed.

116 Carr 2005, p. 211.
117 Tovey 2009, p. 248–52.
118 These "dutch dolls", as Carr called them, hung in her studios in Vancouver and Victoria. A painting of one of them and one of the dolls (with missing limbs) are in the Royal BC Museum's collections.

Continued on page 114

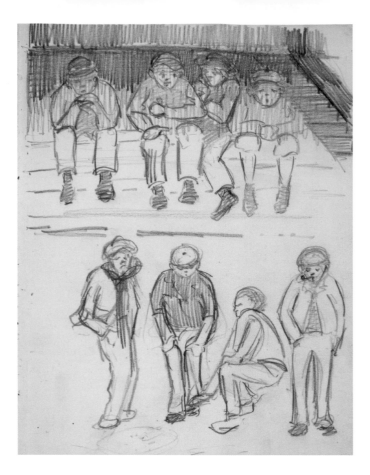

Groups of boys, St Ives.
Emily Carr, graphite on paper, 1901; PDP05856.

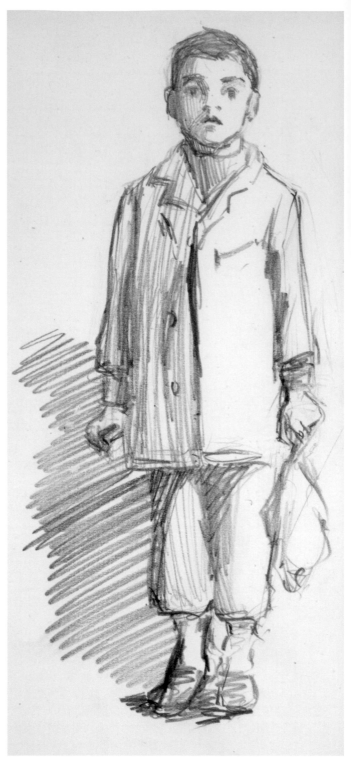

A boy holding his cap.
Emily Carr, graphite on paper, 1901–02; PDP05859.

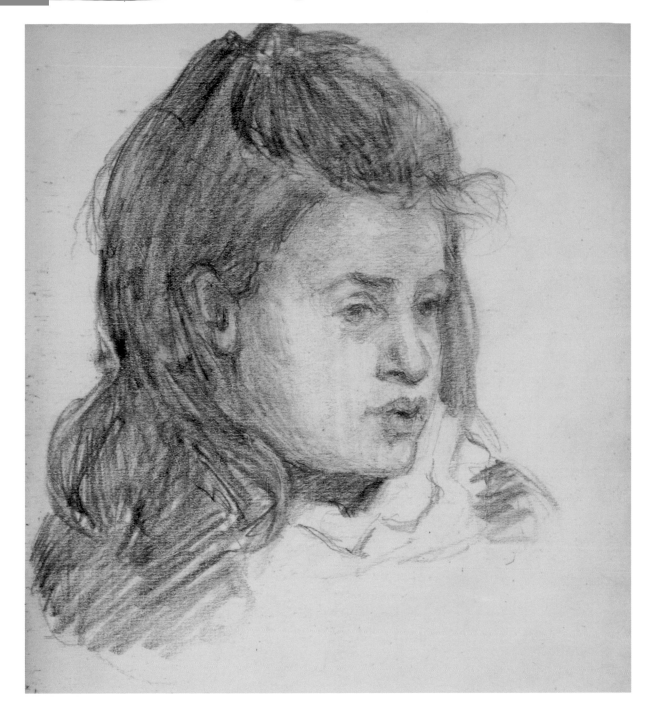

Portrait of a girl.
Emily Carr, graphite on paper, 1901–02; PDP05975.

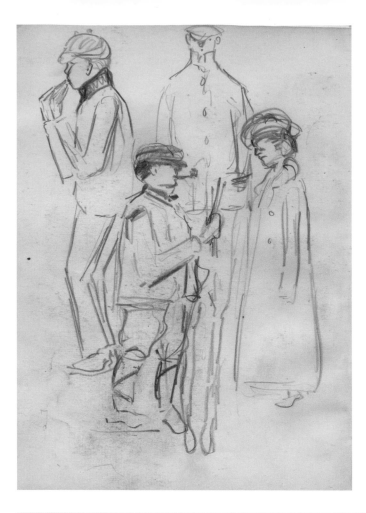

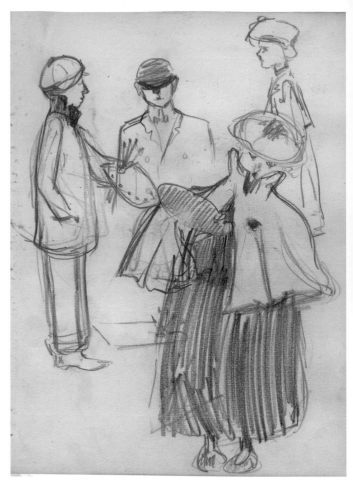

Above:
Fellow students?
Emily Carr, graphite on paper,
1901–02;
PDP05866 (left) and PDP05867..

My Dutch Dolls
Carr's sitting room in St Ives.
Emily Carr, graphite on paper, 1901–02;
PDP05935.

Hilda Fearon and the St Ives cats.
Emily Carr, graphite on paper, 1901; PDP05858.

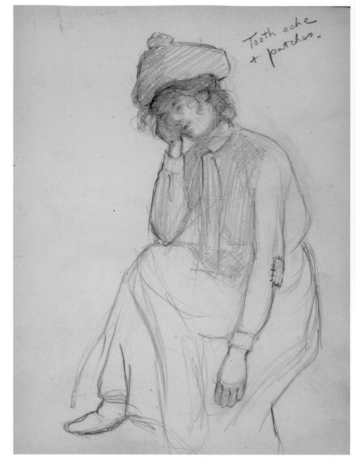

Tooth ache
+ patches.

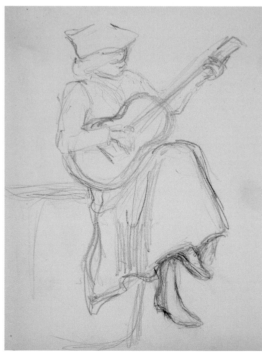

Clockwise from top left:

Portrait of a girl.
Emily Carr, graphite on paper, 1901–02; PDP05884.

Tooth-ache & Patches (possibly a self portrait)
Emily Carr, graphite on paper, 1901–02; PDP05950.

Girl with guitar (possibly a self portrait).
Emily Carr, graphite on paper, 1901–02; PDP05908.

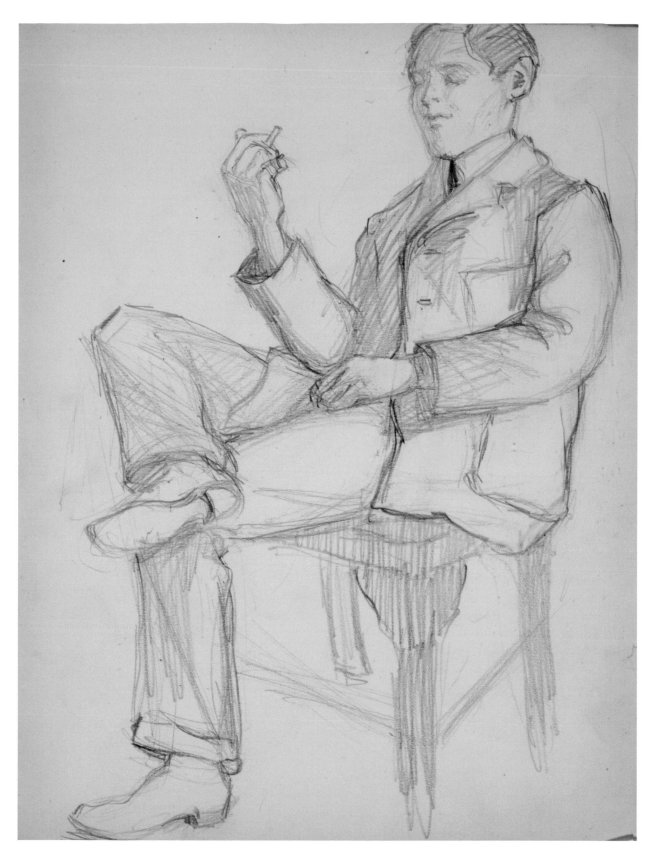

A fellow art student?
Emily Carr, graphite on paper, 1901–02; PDP05949.

Hilda always came with out her purse when we had fisher children in to my suite room as models. and she always forgot to settle for her share of the oil for the extra lamp. The same as the students at Westminster were always having to get some where in a desperate hurry and could you lend them a shilling. but it was goodbye shilling forever. I always kept any material supply well up though I have very little income and go on. I always had a "spare" in reserve for if a canvas was a failure. In England I found I could not keep reserves in the school. They were always borrowed & by the better class students who did not have to scrimp but were indolently careless and who never dreamed of returning their borrows. In S.F. we had borrowed & loaned freely but every one remembered to repay. And maybe but the English students were to my understanding in Petty honor. Probably it was more selfish indifference than dishonesty but it boiled me up.[119]

Fearon stayed on in St Ives until 1907 and moved to London with Talmage at the break up of his marriage. She met with acclaim at the Royal Academy, exhibited at least 18 works from 1901 to 1917. Her art moved away from landscape painting as she gravitated toward portraiture in both watercolour and oils, for in figure studies she made a lasting mark. It is tempting to speculate about the role of those evenings in Carr's rooms where the two of them sketched village children. Fearon died unexpectedly in 1917.

Like Hilda Fearon and most of Carr's classmates, Noel Simmons was younger than Emily yet had previous schooling that stood him in good stead in St Ives. He later studied at the Slade and exhibiting at the New English Art Club.[120] Unmarried, he enlisted in the Great War and in 1916 died in the Battle of the Somme. Simmons featured in Carr's recollections of her time in St Ives, as he also worked in landscape and shared her painting sites. She wrote about one day in particular.

There was a huge white sow that roamed Tregenna. I carried my lunch and shared pieces with the sow. Sometimes Noel worked up in Tregenna Woods too.

One day a frightful thunder storm came with teeming rain. I was trying to sketch under a bush when I heard Noel whistling.

"Hoo Hoo! I shouted. Got any shelter?" "I am under the 2 plank bridge better than nothing come on." No matter how you moved the water poured between the two planks and always aimed down your coat collar.

"Tell you what let's make for that bunch of low buildings other side the brick wall." said Noel. In the lull of the storm we ran. It was easy for Noel's long legs but I had some job scaling the high brick wall we tumbled over the other side to elsewhere. It was pig pens the old sow lay on the straw she gave a grunt or two as we scrabbled over the wall but made no comment as we doubled up & got in beside her. It was so funny to see the very tall elegant Noel doubled down like a concertina out of breath beside the

119 Carr n.d.
120 McConkey 2006, p. 90.

sow. I was warned later that we had done a most dangerous thing.

"Why an old mother pig is safe enough? Besides she was a friend of mine."

"Not always safe by any means said the farmer. She had you at her mercy completely."[121]

Carr immortalized the sow in a poem and two watercolours, shown on the next two pages.

Shocked that Carr chose to stay in St Ives over the Christmas break, when many of the students returned to their homes, Simmons may have observed that she was lonely and perhaps a little sad, so he kindly invited her to stay at his family home the following summer. It appears that they kept in touch after she left St Ives. Later, in 1902, when Carr became ill, Noel's mother visited her at the Crompton-Roberts' home in Belgrave Square, where she convalesced, and then arranged for Emily to be brought to their own residence in Weybridge. To visit an ill friend of one's son is more than a duty call, and then to provide care for many weeks after illustrates that Carr was considered a friend, and a friend about whom friends worried.

Two of the three Australian male artists appear by name in Carr's writing and sketches. The other, Hayley Lever, has been confirmed just recently though references made by other students. Lever arrived in St Ives late in 1899 to study

under Olsson. He left St Ives for Paris in November 1901, not returning until the following March, so in all he was only in St Ives for the first few months of Carr's time – this perhaps explains why Carr did not mention him by name. All three appear by name on occasion in the local weekly newspaper, as cricket players on the St Ives team and in other non-artistic activities indicative of their longer-term integration into the local scene, as they resided in the village over several years.[122]

William Ashton, was born in Britain but raised in Adelaide, Australia, where his artist father tutored him privately. In search of more serious study, he travelled to England, and in 1899 arrived in St Ives specifically to work under Olsson, with whom he evidently got along well both socially and as a pupil. Ashton had his own studio on St Andrews Street, across and down the road from Carr's lodgings with the Curnows. In 1904 "he had first successes at both the Royal Academy and the Paris Salon".[123] After returning to Australia, Ashton held shows of his English work to great acclaim. He had a stellar career in the arts and was knighted for his contributions.[124]

Arthur Burgess, the other Australian, also roomed with the Hodges at the Tregenna Hotel, so shared the dining table and common areas with Carr until she moved to the Curnows'. He and Carr seem to have had a friendship, indicating that

121 Carr n.d.

122 For instance, on August 10, 1901, the *St Ives Weekly Summary* lists Lever, Burgess and Ashton as members of the St Ives cricket team. David Tovey deserves credit for sleuthing Lever's presence in the 1901 class of Olsson and Talmage.

123 Tovey 2014, p. 5.

124 Ashton collected Cornish works and those of his fellow students, which over the years he donated to public institutions. No works by Carr are yet known to have been in his collection. For further information on Ashton, see his autobiography (Ashton 1961).

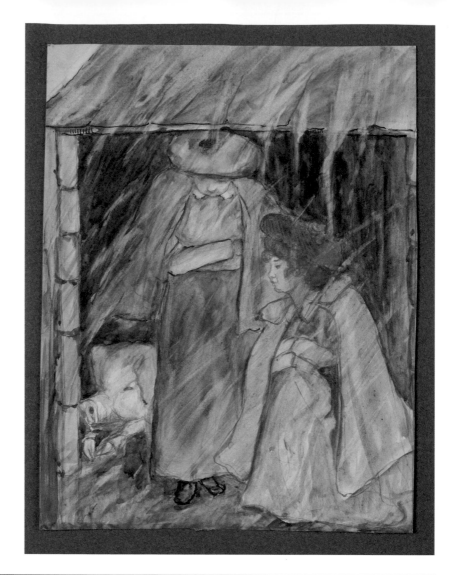

I am a Colonial and have heard the English say
"Colonials have no manners", your advice then lend me pray
One day my pathway led me into a lonely wood
Twas far away but fine the day and good
And yet your English cliamate is full of whims and so
Down poured the rain and I must into shelter go.
I meet another student in the same plight as I.
The nearest refuge that we find is but an old pigsty
A placid Sow lies sleeping upon the scattered straw.
We enter, and take shelter within the open door
She shares with us her little pen. hospitable and kind.
For full an hour while lasts the shower.
We warmth and shelter find.

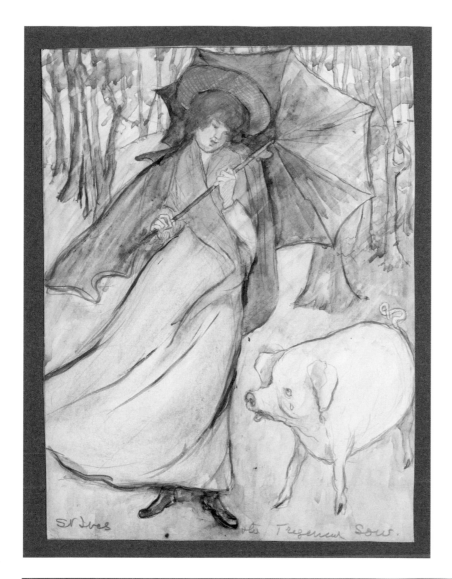

Once more into that wood I wend my lonely way
 Once more comes on a heavy shower from the sky I'm far away
But today I need not flee my umbrella is with me
 Now while I shelter thus enjoy I hear a grunt close by
Good Mrs Sow is waddling past the owner of the sty
 The rain is pouring down her back and dropping from her ears
And rolling down her fatted cheeks like showers of briny tears
 And this is now my question answear Englishman wilt thow?
"Should I share my umbrella with that fat and soaking sow?"

The White Sow of Tregenna Woods, St Ives
Emily Carr, watercolour, 1901–02; PDP10254.

she was accepted and considered one of the group. And luckily for us, he mentioned Carr a few times in letters to another artist he had met in St Ives, who would later become his wife. Burgess's letters provide us with the first direct – albeit tantalizingly brief – personal observations of Carr in England. In the autumn of 1901 he wrote: "We have a new student, a Canadian…. She is neither young, handsome nor thin."[125]

The winter of 1901–02 included at least two major snowstorms, blocking the rail line to London and downing communication lines. It afforded an unusual situation in St Ives, as snow stayed on the ground for several days in a row. Burgess references a short excursion with Carr, giving another brief glimpse of adventure, this time a non-artistic one.

> We have had any amount of snow here. It snowed last Sunday week & there is still or was snow for over a week. I did one sketch up at Knill's Monument. I dragged Miss Carr up. We scrambled over rocks & walls (Miss C is not active) & eventually reached the top warm but rather tired. We snowballed one another a little.

Burgess and Carr had a pact. He would protect her from the overtures of a proselytizing villager and she would ensure he was never alone with "the Frenchman," who frightened Burgess with effusive cheek-kissing. Soon after Carr left St Ives, Talmage and Olsson recommended that Burgess, like Ashton, move on to the Slade School for more challenges. When it was known he was to leave, poor Burgess, without Carr to protect him, received an emotional farewell. "The Frenchman made a fool of himself in my studio. He embraced & kissed me – Fancy me being 'hugged & mugged' by a Froggy-Frenchy – Ugh! I told him in my best French not to be a fool & that I would not stand it, so since then we have hardly seen one another."[126]

Burgess remarked in a letter when Carr left St Ives: "Miss Carr returned yesterday morning. I am very sorry she has gone. She was about the only one I had to talk to in the studio." He himself left for London soon after and met up with Carr in April. She was not at Bushey but back in London at the Westminster School of Art, an establishment he found to be odd as it shared premises with the Royal Architectural Institute, whose collections of salvaged bits and pieces of ancient architectural details were stored in hallways and corners, creating a strange atmosphere that Carr also mentioned in *Growing Pains*. Burgess wrote, "I called on that Miss Carr, the Canadian who was at St Ives. She works at Westminster. What a weird place it is. All among casts of Mummies & old pieces of Architectures. And such '*freaks*' & strange noises they made."[127]

Carr created a series of ten sketches and verses, called "The Olsson Student", in which she mocks her much-patched art clothing and the accoutrements she took with her on forays into Tregenna Woods. Another sketch depicts the class working indoors alongside a wood stove on a wet winter day (see page 104). She names the students and gives us a glimpse into the personal dynamics.

125 Arthur Burgess to Muriel Coldwell, 3 November 1901 (this and the next quotation). Private collection.

126 Burgess to Coldwell 18 February 1902 (this and the next quotation). Private collection.

127 Burgess to Coldwell 14 April 1902. Private collection.

Continued on page 129

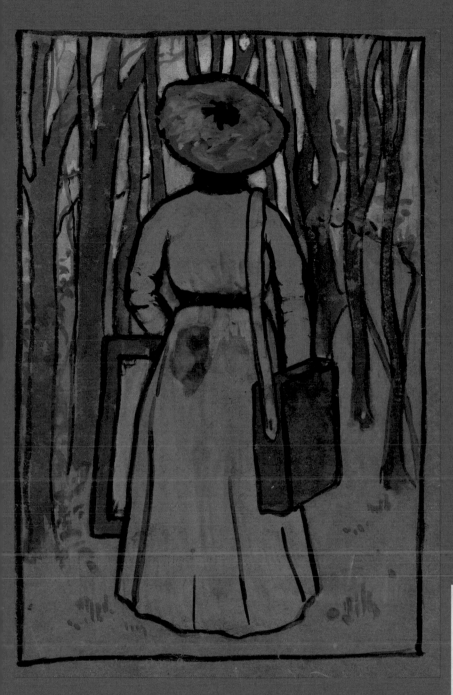

The Olsson Student
This series of verses and paintings features
Noel Simmons, Arthur Burgess,
Hilda Fearon, Will Ashton and Marion Horn
watching Carr enter Tregenna Woods.
Emily Carr, gouache on paper, 1901–02;
PDP06118-6127.

This is the gown
with a hole burnt brown
That was worn by an
Olsson student.

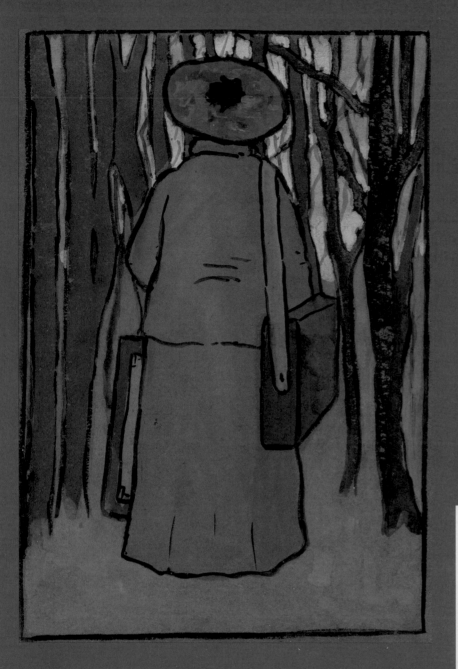

This is the coat
Of a date remote
That covered the gown
With a hole burnt brown
That was worn by an
Olsson Student.

This is the Cloak
With the seams all broke
That covered the coat
Of a date remote
That covered the gown
With the hole burnt brown
That was worn by an
Olsson Student.

This is The cape
Of an antique shape
That covered the cloak
With the seams all broke
That covered the coat
Of a date remote
That covered the gown
With a hole burnt brown
That was worn by an
Olsson student.

This is the gamp
For a rainy Tramp
That covered the cape
Of an antique shape
That covered the cloak
With the seams all broke

That covered the coat
Of a date remote
That covered the gown
With a hole burnt brown

That was worn by an
Olsson Student.

This is the cap
That got wet through the gap
In the side of the gamp

For a rainy tramp
That covered the cape
Of an antique shape
That covered the cloak
With the seams all broke
That covered the coat
Of a date remote
That covered the gown
With a hole burnt brown
That was worn by an
Olsgon Student.

This is the mit
Of no special fit
That put on the cap
That got wet through the gap
In the side of the gamp
For a rainy tramp
That covered the cape
Of an antique shape
That covered the cloak
With the seams all broke
That covered the coat
Of a date remote
That covered the gown
With a hole burnt brown
That was worn by an
Olssen Student.

These are the shoes
In the wet she doth use,
Which like the mit
Had no special fit.
That put on the cap
That got wet through the gap
In the side of the gamp
For a rainy tramp
That covered the cape
Of an antique shape
That covered the cloak
With the seams all broke
That covered the coat
Of a date remote
That covered the gown
With a hole burnt brown
That was worn by an
 Olsson Student.

126

This is the clock
To tell her the time
That swings from her belt
On a stout piece of twine
That ticks o'er the shoes
That in the wet she doth use
Put on by the mit
Of no special fit
That put on the cap
That got wet through the gap
In the side of the gamp
For a rainy tramp
That covered the cape
Of an antique shape
That covered the cloak
With the seams all broke
That covered the coat
Of a date remote
That covered the gown
With a hole burnt brown
That was worn by an
Olsson Student.

These are the Students
Who laughed at her gear
But now they have left
Doth she wish they were here
To jeer at the clock
To tell her the time
That swings from her belt
On a stout piece of twine
That ticks o'er the shoes
in the wet she doth use
Put on by the mit
Of no special fit
That put on the cap
That got wet through the gap
In the side of the gamp,
For a rainy tramp.
That covered the cape
Of an antique shape
That covered the cloak
With the seams all broke
That covered the coat
Of a date remote
That covered the gown
With a hole burnt brown
That was worn by an
Olsson Student?

Carr's written references to Julius Olsson are alternately infused with negativity and appreciation. It is difficult to determine how much of the legend she built around her interactions with Olsson stems from personal incompatibility and how much comes from her own perceptions of social snub. Olsson was certainly more comfortable around the male students, and he may not have offered Carr the same opportunities as he did the men. He was a sailor and often took students out in his own boat. But Carr had a propensity to seasickness, so such outings would not have appealed to her. Carr's unpublished "Growing Pains" manuscript opens with a word sketch about Olsson that leaves the reader with no doubt that even over the passage of time, she recalled and held close the snubs and tension in her relationship with this teacher. "Olsen was History. He lived up on the hill in a fine house. His wife called on all the worthwhile students and asked them to tea. She never called on me." A few pages later, Carr recounts one of the social events just prior to her departure from the school.

> At the term end Julius & Mrs Olsen gave an evening party the studio was invited en masse.
>
> "I won't go," I said but Hilda prevailed & I went with her. It was not very nice – our hostess, was saying goodbye to us.
>
> "I am very sorry I did not get to know you sooner," said Mrs Olsen.
>
> "Oh I've got along very well," I replied.
>
> "You should not have said that." Hilda told me as we walked home. "She's an old snob." I retorted. "It is dreadfully 'colonial' to show her you thought so. Colonials are crude."
>
> "At least we're honest," I flashed.[128]

Carr may have not hit it off with Olsson or appreciated his emphasis on bright light and marine subjects, but she did respect his teaching. "The atmosphere of Julius Olsen's studio was stimulating. He inspired us to work…. [Although] I never liked J.O. much … I respected his teaching and the industry which he insisted that his students practise and which he practised himself."[129] But it was Algernon Talmage who got through to her and made a lasting contribution. He "gave me very good lessons on my Woods stuff. I worked very hard & deep. That I suppose was the beginning of a love which has deepened & strengthened all my life. For that is where I determined to learn to express the indescribable depths & the glories of the greenery the coming & going of crowded foliage that still had breath spaced between every leaf."[130] It was to Talmage that she wrote nine years later for advice on her own studio teaching.[131]

Talmage was the same age as Carr. He and his wife, also an artist, lived in St Ives with their young children. Unknown to Carr in her first months there, Talmage's wife closely resembled her:

> In looks I was very like Mrs Talmage. Same build & coloring. She was very deaf. At first I was very astonished when people caught up to me in the street and roared Hello! in my ear. After a sentence or two they would apologize & fall away. The store people would say, "Send it

128 Carr n.d.
129 Carr 2005, p. 211.
130 Carr n.d.
131 Algernon Talmage to Emily Carr, 1910. MS-2763, BC Archives.

to Mr Talmage's studio or the house?"
Eventually Hilda Fearon explained.
"What is all this?" I said. "Has no one
told you?" "Told me what?" "That you
are the image of Mrs Talmage. I had not
then met Mrs Talmage but when I did
I saw it myself. We might easily have
passed as twins.[132]

Over the winter months, students
worked on spring submissions to the Royal
Academy and Paris galleries, but also for
the annual March Show Day when St Ives
artists hung their best works. The *St Ives
Weekly Summary* noted on December 14,
1901, "that the artists of St Ives are busily
engaged on their winter work, preparing
for next year's Royal Academy and other
exhibitions." One would assume that Carr
herself might have also tried her hand at
polishing a favoured scene and considered
submitting.

That Christmas break, Carr remained
in St Ives while most of the others went
home for the holiday. One of the other
students, Albert (possibly Alfred Bentley;
see pages 105–06), also remained and
together they did a little sightseeing, taking
the opportunity to visit nearby villages,
augmenting Emily's earlier excursions with
Alice. She wrote:

> I took several excursions round about
> before leaving St Ives in March. I wanted
> to go to Lands End the very name of
> it, its stick out on the map appealed to
> me but the summer excursion was not
> on but I went to St Earth, the rat hole,
> and a place whose name has gone from
> me but that has haunted me ever since.
> One of the boys & I went. There was a
> little steamer. In dreams I've boarded

Emily at St Ives, 1901–1902
Alfred Bentley sketch, printed in *The Week*
(Victoria) to illustrate an article on Carr, February
18, 1908.

> her again & again. The little town was
> huddled together & bleak there was one
> quaint old place you went down steps
> under the street it was sort of a ship.
> You turned round inside & came out
> on a different street. It was very dark &
> perplexing inside. There was a scatter of
> fishermen keeping appointments with
> tides. And shrewd Cornish children
> racing about shrieking in gibberish you
> could not understand.[133]

Carr worked hard on her sketches of
Tregenna Woods. She thought she made

132 Carr n.d.
133 Carr n.d.

good progress, but when Julius Olsson resumed instruction after an extended vacation in Sweden, he was in a grumpy frame of mind – perhaps the result of a bad toothache – and almost all of the students received negative critiques of their work. "'Maudlin! Rubbish!' He bellowed pointing with his dead pipe at my canvases. 'Whiten down those low-toned daubs, obliterate 'em. Go out *there*,' (he pointed to the glaring sands) 'out to bright sunlight – PAINT!'"[134] Carr soon realized she was not singled out, but that Arthur Burgess and others too met with his displeasure. Burgess she found crying in his studio, bemoaning the money he had spent on a gilt frame for the picture he had anticipated submitting to the Royal Academy in a few short weeks. "There was a long silence. Then we looked sheepishly into each other's red eyes and both began to laugh."[135] Within the hour they both resumed their painting. "I'm hungry as a hunter, Burgess. I'll run home for a bit, then the sun will be just right for painting those cottages."[136]

After he had his tooth extracted, a happier Olsson found her in the Down-along part of town, her easel set up in the Digey, a steep and winding narrow lane.

> The sun was shining down the Digey.
> J.O. found me there an hour later I heard his heavy tread on the cobbles paused behind my stool I could not look up.
> "Fine! Fine! That's colour that's sunshine. Why didn't you do work like that when I was away – dark dismal woods baa!

Newrotic morbid." That was not the first time since I came over to England I had heard that same story expressed. What was it the English were afraid to face in the woods? They herded together in cities. What would our Western Canadian woods do to them, I wondered. Well I'd study where they wanted me to while I was in their land but I was going to work it out myself one day – face our Canadian woods, the English woods were only half woods anyway. The deepness had been "prettied" out of them – some day I vowed.[137]

Carr left St Ives a couple of months later. She had no finances to afford the required gilt frame to submit to the Royal Academy, and as much as she respected Julius Olsson as an artist and as a teacher, she realized that her own priorities were not his. Algernon Talmage had provided her with positive support when he legitimized her desire to paint in the woods, and that was enough for her. The inclement weather made working outdoors unpleasant. It was time to return to London and the Westminster School of Art where she could draw indoors until the weather improved. She began the long train journey to London, and once there "I cabbed heavily to Bulstrode St and established myself in a cubicle, stored my St Ives studies in the Bulstrode basement at tuppence per trunk per week."[138]

Cornwall, she later wrote, "is a memory, a keen air quaint poor people with

134 Carr 2005, p. 214.
135 Carr n.d.
136 Carr 2005, p. 216.
137 Carr n.d.
138 Carr n.d. Perhaps she left these canvasses there and never brought them home to Canada.

a tang of melancholy pervading them, stone cottages pink blue or white washed, cobble streets & broken stone walls and always the sea pounding."[139] But Cornwall was also a series of direct and indirect personal connections that would play roles in her later life. She kept in touch with Algernon Talmage, for instance, who, although not Canadian, was in 1917 appointed an official war artist for Canada. Sophie Pemberton from Victoria spent sketching months in Polperro, not far from St Ives, possibly even at the same time as Carr was in Cornwall. Certainly she had much in common with Carr in their English studies.[140] Canadian artist Helen McNicoll spent 1905 in St Ives. Carr may have bumped shoulders with her years later in Toronto. British watercolourist Charles John Collings was there in 1907; he subsequently moved to British Columbia in 1910 and exhibited in Vancouver at a time when Carr resided there. Harry Britton taught in St Ives and later returned to Canada. He and Carr may have met in 1927 when she was in Ottawa. New Zealand artist Frances Hodgkins (who in 1911 became Carr's teacher in France) missed meeting Carr by mere weeks when she attended a "show day" on March 24, 1901; she moved to St Ives soon after.[141] Eric Brown, director of the National Gallery of Canada who visited Carr in her Victoria studio in 1927 and was credited with her discovery, was the younger brother of famed St Ives-based

artist Arnesby Brown, an important figure in the art colony while Carr was resident.[142] It would not have taken Brown and Carr long to discover this connection. Even Marion and Fred Redden "liked Arnsby Brown's cow pictures very much" when they visited the Royal Academy shows.[143] Likewise the connections of St Ives and Bushey to artists – Talmage, Whiteley, Brown and others – enabled Carr to move easily from one community to the other. Shared art masters and emphasis on the landscape and the new tools of art teachings and techniques from France provided a common base of experiences and a shorthand for introductions that enabled Carr's legitimacy.

Burgess visited Emily at the Westminster School in April 1902, but very soon – with the advent of more consistently fine weather – she moved again to Bushey and resumed studies under John Whiteley. The wonderful story in *Growing Pains* about her friendship with a young student she names as "Milford" dates from her 1902 visit, because Milford had been directed her way by her art friends in St Ives.

A new student blew into the studio from St Ives. He said "I have a recommendation for mercy from the St Ives students to you." His name was Milford. He was a delicate boy his mother had remarried & his step father was impatient of the boys desire to become an artist but his mother was

139 Carr n.d.

140 Beanlands (née Pemberton) 1904. Pemberton probably visited Cornwall on a number of earlier occasions.

141 Gill 1993, pp. 122–23, 165.

142 I am indebted to David Tovey for drawing my attention to this connection. Tovey 2009, p. 134.

143 Carr 2005, p. 185.

in full sympathy. Before long she came to spend a week with her son & I got to know her quite well.[144]

Harold Milford Norsworthy (1886–1917), born in Wandsworth and raised in Cornwall, "was inspired by seeing artists at work to become an art student" himself.[145] He was 15 years old when he and his mother arrived in Bushey to register him for figure classes. His widowed mother had remarried a few years previously to a much younger man, who sent Milford and his five siblings away to private schools, and in Milford's case, after completing school, to begin art studies. Mrs Norsworthy, Carr recalls, asked Carr to take him under her wing:

> "Look after Milford," she said. "Do see that he eats slowly and take care of his money. He spends it all when he first gets it & then has nothing." So I banked his money. He handed his allowance nearly all to me when it came…. We got along famously. He had lodgings down the street and moved his table by the window where he ate his meals conversing to any students who passed I would yell in passing. "Milford are you going slow and taking lots of chews?" He'd stick his head out munch munch munching to show me….

> We often went out into the fields together to work. One day I was working one side of a hedge & he on the other. He called across & asked me to give him a crit. To do so I had to walk to the far end of the field to find a gap in the hedge. When I came back a cow had knocked my easel over and was sitting on the canvas. How we laughed.[146]

Carr created a watercolour triptych, titled "A Study in Evolution – Bushey" (shown on the next two pages), depicting an adventure with Milford one day when they were beset by flying insects, possibly dragonflies or mosquitoes.

Carr's unpublished "Growing Pains" manuscript also provides further colour to her 1902 Bushey experiences and contains longer versions of the stories she tells in the published *Growing Pains* about two student sisters she nicknamed "the canaries" and of a chaperoned student in Whiteley's class who was the inspiration for a long satirical poem Carr composed that delighted John Whiteley and his wife (and also the sketch shown on page. 136).

The manuscript also provides information on Carr's lodgings in 1902, which were quite a contrast to those in 1901. This visit she roomed with middle-aged sisters Martha and Elizabeth Mead. The house she occupied with them at 6 Herkomer Road had recently been that of their father, an 86-year-old retired blacksmith who died there only a few months prior to Carr's arrival. She was possibly unaware of the circumstances that these two unmarried women, both in their late forties, now required a paying lodger, but she did not like them much, anyway. "Just as Mrs Dodd was the only nice London landlady I had, so the Misses Meads were the only mean country landladies I had in England."[147] One episode in particular stood out for her

144 Carr n.d.
145 Tovey 2009, pp. 258–59.
146 Carr n.d.
147 Carr n.d.

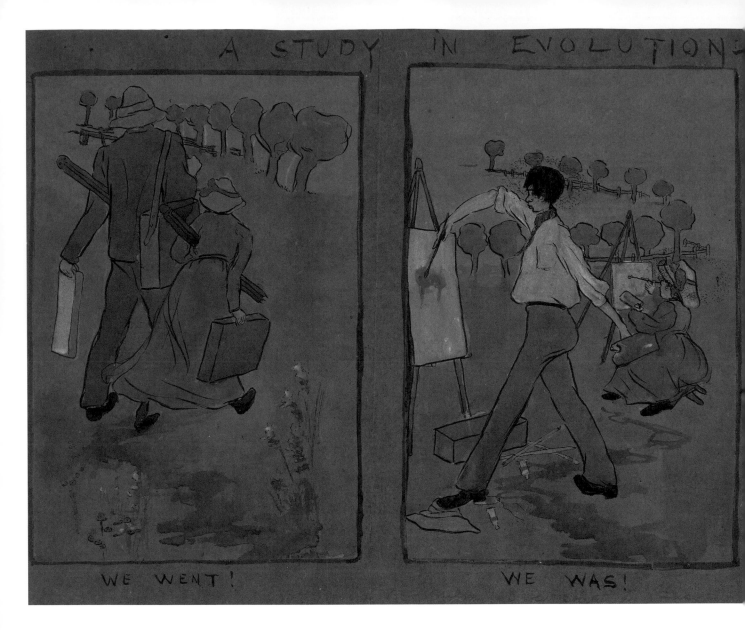

WE WENT! WE WAS!

because it reinforced their uselessness and her young friend Milford Norsworthy's sensitivity. She had crushed her fingers, an emergency that incapacitated the sisters.

One night [Milford] was on the way to an evening class with some other students.… He said afterwards, "You stood right before me in the path & I knew you wanted me." Milford turned abruptly. "I'm going back for Miss Carr."

"What for? You never call for her on the way to night classes?"

"I'm going to tonight." And back he came.

It was a white faced me he met at the door, a folding chair had crushed my fingers by collapsing. The old Miss Meads were making little dabs at it with a filthy dishcloth and saying "Oh Lor, Oh Lor." Milford put me on the sofa &

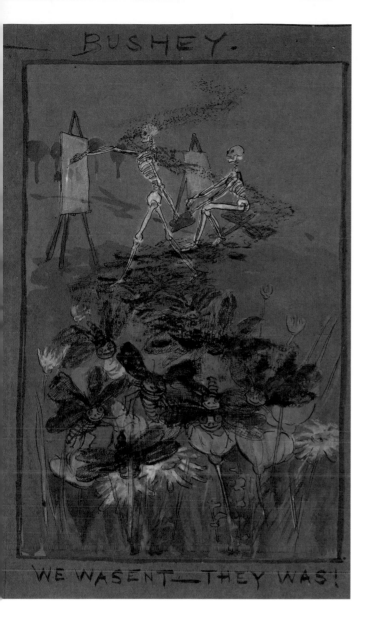

BUSHEY.

WE WASENT—THEY WAS!

A Study in Evolution – Bushey
Featuring Carr and Milford Norsworthy
Emily Carr, watercolour and ink on paper, 1902;
PDP06157-6159.

ran out for brandy. I was deadly faint &
the shock gave me a terrible pain in the
stomach. Milford gave me the brandy
and sat down with his back to me, did
not talk or notice that I was crying. [148]

Milford Norsworthy's mother asked
Carr to look after his general health and
finances. But Milford became her good
companion, as well as a sketching partner,
and he looked out for her. For a woman

whose world would soon spiral out of
control, Milford's caring action showed her
that she was appreciated. Evidence suggests
that Carr stayed in Bushey and attended
art classes through to the summer. She
may even have anticipated returning to St
Ives, but her own chronology for 1902 is
confusing. Perhaps she had pushed herself
too hard or became ill from inclement
weather, but she returned to London in a

148 Carr n.d.

135

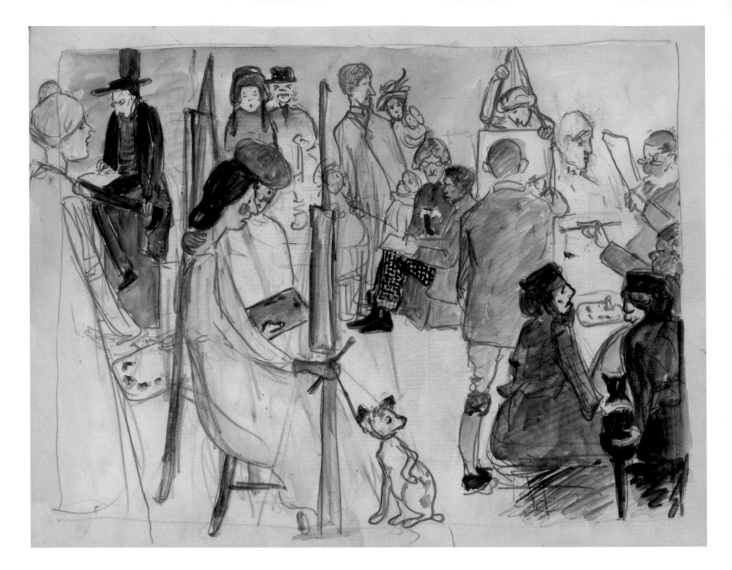

Imagine if every student brought a chaperone to class.
Emily Carr, graphite and watercolour on paper, 1902; PDP06140.

weakened state. Carr wrote variously about illnesses, about the effect of returning from the countryside to the city.

Always as I approached London the same feeling flooded over me. As we left the fields & streets and houses began to huddle closer & closed and the breath of the monstrous factories the grime & smut & smell of steam came belching toward you by swift degrees. You saw the creature solidify from the train window. Spots spread into a smear the smear solidified you slid into the station and were swallowed into the stomach of the fearful monster a grain of fodder to nourish it's cruelty. No more you are an individual but you lost in the whole part of its cruelty part of it's life part of its wonderfulness part of its filth part of its sublimity & wonder though it was not aware of you any more than you are aware of a pore in your skin. People said Marvelous city!

Hub of the world. She drew people to her running they came, proud & glad to have her take them. A minute revolting atom like myself was less to the monster than the greying of one of his hairs.[149]

Whether the illness was repetitive, whether it really was that she was stronger living outside of cities, is hard to know for certain as later in life, and while writing *Growing Pains*, this idea of unexplained weakness became a repetitive theme, colouring her entire recollection of England. Years later she recalled different incidents, perhaps blending them so they variously occurred at the Cambridge home of the Watts, at the Westminster School, at Bulstrode Street. The conclusion is the same. On more than one occasion she became too weak to function. What seems clear is that by June 1902 she had spent some time bedridden at the home of Westminster Art School pal Mildred Crompton-Roberts at Belgrave Square, and after several doctors were consulted, she was perhaps encouraged to convalesce outside the city at the home of Noel Simmons and his family. Eventually a telegram wired to Victoria informed Emily's sisters of her situation, and within a month Lizzie arrived to take control.

Lizzie arrived in London at Euston Station after a three-week journey. She called upon Mrs Crompton-Roberts "to thank her for her goodness to Millie in her illness", then continued from London to the Simmons home in Addlestone, near Weybridge, Surrey. Two of the Simmons boys "were at the station to meet me with their motor car & Mrs Simmons gave me a

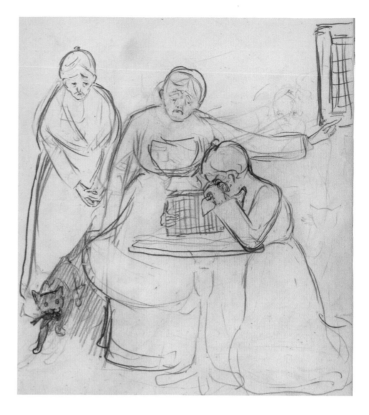

Carr with her fingers trapped in a folding chair. Emily Carr, graphite on paper, 1902; PDP06133.

kind, warm welcome as soon as I reached their door & took me up to see Millie who is in bed still ill. I have a bed in Millie's room."[150] A few weeks later they arranged for a nurse, Miss Begg, to live with them at Mrs Tilley's "Woburn Cottage", which they rented. Emily arrived from the Simmons household "in a wheeled chair & is none the worse for the change."[151] The nurse and cottage (the beginning of a family financial commitment) enabled the sisters to be self sufficient, grateful to friends and conscious of debts of kindness. On August 16, Hannah Kendall came from London to stay for a short visit, possibly hoping that she could help her friend.[152] Other friends followed suit.

149 Carr n.d.
150 Lizzie Carr's diary, 13 July 1902. MS-2181, BC Archives. Voyage dates from online passenger lists confirm that Lizzie left Victoria on June 27 and arrived in Liverpool on July 12.
151 Lizzie Carr's diary, 9 August 1902.
152 Lizzie Carr's diary, 16 August 1902.

Emily's doctor advised that she recuperate in the country but not be moved very far. Lizzie scouted out Hindhead, and after a full day of searching found places in a guesthouse there, and so they moved. It was 30 minutes by train and they arrived in time for tea, but "Millie went to bed with a bad headache after & stayed there, not able to get up for dinner."[153] The sisters stayed in Hindhead a month, until early October, then headed to Addlestone overnight and another consultation.

> Dr Viney came to see Millie gave her
> some new medicine & quite approved
> of her going to Richmond for a time
> … so we left Addlestone at 3, drove
> to Shepperton & from there went to
> Richmond, half-an-hours ride. Drove to
> "The Homestead", 20 Shun Rd. Millie
> has a room on the third floor in the
> house proper & I one in the house across
> the street.[154]

The sisters quarrelled, neither used to the enforced cohabitation. By mid October Lizzie had been in England with Emily for three months and Emily's condition seemed not to improve in any great way. Once in Richmond, close enough to London for Emily's friends to visit but far enough out to feel country-like, Lizzie succumbed to temptation and made little effort to stay with her sister, embarking on greater and longer absences. With new-found friends, Lizzie enjoyed bicycle trips, shopping in London, sightseeing, concerts and musical evenings. Reading between the lines in these diary references, Emily's hand is evident as she enabled Lizzie's absences

through gifts. Lizzie attended the "Royal Procession" of Edward VII through the streets of London. "Millie gave me a present of a ticket for a seat at the Canadian stand." Then, on Lizzie's birthday "Millie gave me £1 toward my sailor dress & a pretty lace collar."[155] On November 17 Lizzie headed north by train to Edinburgh and then Perth, enroute to Coupar Angus and a relaxing visit with the Anderson family. Almost a month later, on December 16, she was abruptly recalled. "Received word by the morning post that Millie is not so well."[156]

When Mrs Crompton-Roberts contacted Emily's sisters to report her illness in June, Emily did not expect that it would be Lizzie who came. "Oh why isn't it Alice?" she wailed. She and Lizzie were like chalk and cheese.

Emily's unpublished manuscript is a counterpoint to Lizzie's diary, which, although pivotal as an independent record of Emily's movements for the last six months of 1902, the time leading up to her hospitalization, it lacks entirely in emotional connectivity. In her diary, Lizzie notes the basics, reuniting with Emily and making arrangements to move her as required. Lizzie references people without employing fictitious names, another helpful fact. But beyond these rather terse entries, Lizzie becomes expansive in her writing only when it came time to record days she spent without the ill Emily, exploring the sights in Winchester or London. While she leaves a fine itemization of social visits and the nooks and crannies of the various

153 Lizzie Carr's diary, 2 September 1902.
154 Lizzie Carr's diary, 8 October 1902.
155 Lizzie Carr's diary, 25 October and 6 November 1902.
156 Lizzie Carr's diary, 16 December 1902.

"national astonishments", she says little in her diary about Emily. She did not write directly of her opinions or supposition concerning Emily's condition, perhaps because she knew the diary might be consulted by her sisters upon her return, or perhaps it was just her way of hiding emotion. Although the sisters loved one another, they did not appear to understand each other beyond awareness of individual difference and incompatibility.

Emily left her own impressions of those first days when her sister arrived in Addlestone.

Lizzie & I never did hit it off. She was a very very good woman religion sticking out of her everywhere. She pierced you with sharp little darts of it incessantly. She was much distressed at my condition and wished to read the bible and pray with me all day. She fetched in a miserable curate & had prayers offered for me in the local church. The curate was insufferable and actually seemed disappointed when he said we prayed for three last Sunday all are recovering.

"I spose he was counting on the funeral fees." I snapped.[157]

Lizzie was apparently, for unspecified reasons, emotionally and physically vulnerable and Emily worried about Lizzie's suitability as the one who flew to her assistance.

Lizzie was herself on the eve of a nervous breakdown they had sent her thinking the change would brace here. She really was not fit to come. Afterwards she took up nursing but in those days she was quite tactless with the sick. She would creep up behind and suddenly place cold clammy hands on your forehead. She got between my friends & me. Playfully pretending she was humouring a cranky invalid. What made me really angry was the Hipocracy of making out that we were utterly devoted sisters & kissing & fondling me which I loathed and which was not natural to either of us. When I refused these causes she was so hurt she would race off to London and be gone hours over time while I was in a fever of anxiety thinking she was lost or run over which was none too good for me and made me hateful if relieved when she did come in safe and sound. She was desperately homesick there was more illness at home she tried to hurry me well by fussing and called the Dr a fool in not allowing me to travel. All between us was very very uncomfortable we went from one part of the county to another. Richmond, Hindhead anywhere except London which the Dr forbade.[158]

As the recipient of Lizzie's artificial public attentions, Emily was saddened hearing her judgemental opinions. Not only that, Lizzie really didn't appear to comprehend the depth of Emily's illness, which, on the surface manifest as headache and bodily weakness. Lizzie refused to believe it to be anything serious, thinking that Emily somehow malingered.

I am afraid it was really a horrid time for Lizzie and if she only would not have acted up to that 'beloved pal' idea

157 Carr n.d.
158 Carr n.d.

it would not have been half so bad. I did not care if people thought me a crank, or not but I did loathe the hypocracy of pretending all the love and devotions we had never indulged in and I stuck up stark like the pole of a hugging scarlet runner. When we were alone she cried & scolded. She disapproved of my smoking & playing the card game of patience. She urged me to make up my mind I was fit to travel and quarrelled with the Doctor for saying I was not. Those in the boarding houses thought her a saint & a martyr, in their presence she bantered & humoured me playfully. I made no headway.… Lizzie cared a great deal about what people thought. She could not bear my English friends to think her unloving or neglectful. She had kept up that sentimental maukishness of kissing and playful humouring which was not indigenous to our home life and thrown in all the "dears" and kissing indigenous to English homes. It … did not work.[159]

By mid December 1902, when Lizzie was in Scotland, Emily's symptoms worsened, but despite her weakness, she took matters into her own hands. She received notice that the elderly James Lawson, executor of Richard Carr's estate and the Carr sisters' financial "guardian", was in London and was aware (having spoken to Lizzie in Scotland) of her illness. Pre-empting any decision he might make on her behalf – for he controlled the finances for the Carr family

and in a situation quite typical for the time, had authority over the unmarried sisters – Emily decided to consult a London specialist, and so when Lizzie returned, she was ready to do so. Emily had lost all feeling in her right leg and arm[160] and needed Lizzie to accompany her on the train but did not want Lizzie to be present for the consultation. Lizzie reported:

> Millie & I went up to London. Millie went straight to Miss Hill [a nurse who helped Emily at the time of her foot surgery], took lunch there & went with her to see the doctor as they did not want me.… The doctor's opinion is encouraging he says Millie's trouble is mainly a bad nervous breakdown & says there is no reason why she should not get perfectly well in time but it may be some months.[161]

This did not suit Lizzie at all; she wanted desperately to return home and dreaded additional time away. James Lawson visited Emily and then called on Nurse Hill, who reinforced the doctor's instructions. Lizzie recorded that Nurse Hill told Lawson, "She thinks it would be better for Millie to be without me & be with a nurse & a stranger & recommended a convalescent home at Farnham which we are to go & see."[162]

As it turned out, Miss Mangle's Convalescent Home was perfect, but at the last minute the proprietor rescinded her agreement to take Emily when she learned that Lizzie planned to return to Canada.

159 Carr n.d.
160 Carr n.d.
161 Lizzie Carr's diary, 19 December 1902. MS-2181, BC Archives.
162 Lizzie Carr's diary, 23 December 1902.

She "was afraid of money matters being unsatisfactory…. [Millie] was terribly disappointed over the change of plans."[163]

Emily and Lizzie received frightening news from home on almost the same day. Oldest sister Clara (Tallie) had undergone surgery for breast cancer at the beginning of December. Worry for her sister combined with six months of illness made Emily desperate to recuperate.

[She] heard of a large Convalescent home in Suffolk. Miss Hill recommends it & Millie has decided to go down there on Monday & stay a week, & if she likes it stay several months. It is at Naylands, fifty odd miles from London is under the management of Dr Walker, a clever woman with a London practise & the oversight of two convalescent homes, she spends two days a week at Naylands. There is also a resident doctor at the Sanatorium besides nurses & a matron.[164]

Three days later Emily embarked from Liverpool Station for Naylands and the East Anglian Sanatorium, a facility not yet a year old. Six days after she arrived, she wrote to Lizzie that she liked it and would stay. What a relief! Lizzie returned to Mrs Dodd's on Bulstrode Street and made arrangements for Emily's things to be sent to Victoria. She then met up with Emily for a few-hours visit, including dinner with the patients in the dining hall and tea in Emily's room. Lizzie's comments confirm Emily's later description of the sanatorium, its open windows, no fires, but warm bedding and nicely appointed rooms. She approved of the well-cooked food and showed no misgivings at leaving Emily there.[165]

She looks and feels better. They have put her to bed & are giving her complete rest. The Sanatorium is for open air treatment. Millie's windows are all open & she has plenty of hot bottles in her bed & plenty of warm wraps over her. Dr Walker was down & I saw her she is a middle aged woman & likes Millie, & M. her & I am sure they are & will be kind to her, it is very expensive (3 guineas per week) I do hope & trust it will do Millie good…. Left Millie in the best of spirits & quite happy.[166]

Established by Dr Jane Harriet Walker in 1901 to treat tuberculosis patients, the sanatorium was brand new and pioneered fresh-air treatment. In its first years, it also accepted non-tubercular residents like Emily who required complete rest and whose symptoms included stress. In Carr's case, the medical staff advised her to leave art aside, disconnect from her creative side as a means to healing. This was not an easy task. Enforced idleness had to be practised to become the new reality.

In the Sanatorium we lived by rule disburdened of all responsibility even of the care of our own bodies. As near as possible you became a vegetable sun rain & snow fell upon you. The coming of day and night, feeding & being washed. The past – the struggle of work got dimmer & dimmer, till it was a gone dream. There was only an uneventful forever and ever ahead.

163 Lizzie Carr's diary, 6 January 1903.
164 Lizzie Carr's diary, 10 January 1903.
165 Lizzie Carr's diary, various dates in January 1946.
166 Lizzie Carr's diary, 21 January 1903.

When I was first ill the fever of work obsessed me. The Dr forbad me to talk or think of it. I never had talked much about work. My own people were not particularly interested. They had never asked about it in their letters. They were totally indifferent except thought the study from the nude was to them utter nakedness & scandalous. I doubt for the 3 months she was over my painting was never mentioned between Lizzie and I. The environment at the San was certainly not artistic. The whole thing lay dead in my soul.

The surrounding country was meekly lovely. There were small patches of woods which could not help but be lovely pretty bits that soothed one's hunger after the starvations of London like pretty little cakes but failed to satisfy one who craved the strong meat of western forests. The English birds were a never failing source of pure joy. I devised a scheme to take some out to Canada and was permitted to hand rear some from the nest. The San was open air. It was really a T.B. institution tho they took cases like mine where the treatment fresh air quiet & feeding were the essentials.[167]

Author George Gissing, a patient at the sanatorium in 1901, described Dr Walker as short, stocky and full of energy, with a forceful personality.[168] Dr Walker (who Carr called Sally Bottle in *Pause*) attended from Friday evening to Sunday afternoon each week, when she was not at her London Harley Street practice. She conducted her weekly rounds each Saturday. The daily authority to oversee treatment lay with the "house doctor", whom Carr fictionalized in *Pause* as "Dr Macnair".[169] The true identity of Dr Macnair during Emily's stay has not yet been determined, but Carr and the doctor got along well. The most intimate patient-staff interactions occurred with duty nurses assigned to specific patients. Two nurses looked after Carr during her stay there: one was irrationally afraid of spiders and the other had too much compassion. The personalities of these women and of the patients provided plenty of fodder for Carr when she sat down decades later to compose the stories which formed the posthumously published *Pause: A Sketchbook*.

The staff – medical, nursing, housekeeping and gardening – were all female, hired by Dr Walker deliberately as a matter of priority. The patients included both men and women, including some young adults.Emily's relationship with Walker, the house doctor and the nurses – both professionally trained and not – changed over time, from harmonious interactions to resentment caused by the long delay in discharge. As with the rest of her life writing, Emily changed surnames and has made it difficult to

167 Carr n.d.
168 Cited in Vogler 1993, p. 2. Walker was a pioneer in the field of TB treatment and, as an accredited female doctor, a role model for other women. It may be that Emily Carr made a decision based upon Walker's gender and that the sanatorium was female-run.
169 The 1901 census lists Edith Collett in this position, but she was gone by 1903. E. Soltou, Walker's eventual successor at the sanatorium, assumed duties as house doctor sometime after Emily's tenure. Soltou was younger than Carr, too young to have had this post in 1903.

Prepositions not a decent weight this week except Miss Carr + here is indecently decent

The doctors on their Saturday rounds to the patients. Emily Carr, graphite and ink on paper, 1903; McMichael Canadian Art Collections, gift of Dr Jack Parnell, 1973.8.

establish identities of her fellow patients and caregivers.[170] The 1901 census provides a listing for staff, although the patients enumerated were no longer there two years later when Carr arrived. Extant documentation is still very slim, although a few faint pencilled pages in her original sanatorium sketchbook contain a listing of surnames written by Carr as she crafted a funny story for a party entertainment in which the surnames were woven. Some of these surnames match the census, but

many more do not. More research must be undertaken.[171]

Daily life at the sanatorium was based on stable, unchanging routine. We know the sanatorium's daily schedule from Gissing's journal:

Daily regime called for rising at 7:15 am (for those not confined to bed), breakfast at 8, dinner at 1, tea at 3:30, supper at 6:30, with rest or walking between meals, lights out at 9 pm in winter and 9:30 in summer, and no alcohol (unless prescribed), no food between meals, no card playing until after tea, no gambling ever, and no expectorating anywhere but into a mug or flask provided. Visitors were discouraged but permitted on the second and fourth Sundays of the month. There was a chapel.[172]

Carr invested the time to establish friendships with patients and noted their kindnesses. Many patients died of tuberculosis; the culture of constant patient death was in itself melancholy and within it, Emily herself was an anomaly. She was resident longer than most and saw her share of heartache, mourned both the unexpected and expected deaths of fellow patients. It would have been an odd place to rest, as the emotional toll was significant and, over time, wearing. The sanatorium treatment (for its tubercular and nontubercular patients) emphasized bed rest to reduce stress. Carr noted that it was several months until she was

170 Carr wrote about her experiences at least four times: (1) in a sketchbook she kept while there; (2) in a "funny book" she created just after her discharge in March 1904 and gave to "Dr Mac"; (3) in her unpublished "Growing Pains" (Carr n.d.); and (4) in the published *Growing Pains* and *Pause* (Carr 2005 and 1951).

171 The sanatorium sketchbook is in the McMichael Canadian Collection.

172 Vogler 1993, p. 4.

allowed out of bed and to eat her meals in the dining hall. But then she also had physical difficulties when she checked in, intermittent symptoms that had become more constant since the spring (and might have precipitated her flight from Bushey back to London). Weakness in one leg compromised her mobility. Sketches Carr drew of herself in *Pause* show her using a walking stick when out in the garden, presumably for support. The sketches also depict her wearing what appear to be dark eyeglasses, presumably to cut the glare she often complained of that brought on her bilious headaches. These headaches had plagued her most intensely at St Ives, but also in London and Bushey.

In *Growing Pains*, she records that the treatment she received during her tenure shifted from bed rest to include "a great deal of massage, a great deal of electricity and very heavy feeding."[173] Maintaining and especially increasing one's weight was thought to counter the TB. Carr was not exempted from the massive portions that patients had to consume each and every meal. A story in Carr's *Pause* reveals patients secreting food from their plates into empty envelopes that they later dug into the soil in the garden, such was the quantity of food forced upon them. Patients who were mobile were encouraged to walk the grounds; there Emily and others could smoke cigarettes and be largely unmonitored.

Carr remained at the East Anglian Sanatorium for 15 months, much longer than she or Lizzie planned. The discharge notes read: "44 Carr Street, Victoria, British Columbia. Hysteria. Came 12.1.03 went 17.3.04. Result Cured."[174] She emerged not only significantly larger, but with little of her previous self-confidence. She was seriously out of touch with the outside world. And so she fled to Bushey. Moving from the constant presence of hospital staff and patients, with firm and unvarying routine, to a solitary room and an unstructured schedule was a huge adjustment – no wonder she became emotional.

I was in the San for 18 [actually 15] months. Every thing in me dormant. Then when all the ambition & work had been smothered out of me I was allowed to return to work, but ordered to keep away from cities, London in particular and I went down to Bushey again. Returning to work after the long dormant state was different to what I expected the shock of solitary independent life after the sheltered protection of the San nearly knocked me over. I was weak. I took lodgings with a kindly woman but I cried steadily for a fortnight for no reason at all. The classes were not open. There was no one I knew. I wonder what Mrs Lewis thought seeing me cry, cry, cry, the weather was wet. I could not walk far. After one week utterly exhausted from tears I plunged – I got a book and in it wrote and illustrated a ridiculous skit on the San Treatment. The tears were teary down my face all the time I was doing it. I sent it to the little woman house Director at

173 Carr 2005, p. 233.
174 Patient Register, East Anglian Sanatorium, ID507/6/1. Suffolk Record Office, Bury St Edmunds branch, London, UK.

the San. Everyone thought it was very
funny – they went into fits of laughter.
All but the little Doctor. Afterwards
she told me it made her cry. Anyhow
it served the purpose of bringing me
back to work & filling in the ghastly
two weeks before Mr Whiteley's studio
re-opened.

Mrs Redden came from London to see
me and Mrs Mortimer.[175]

175 Carr n.d.

1904 and Home

I have found it no good being frightened over here because there is not any one to fly to for protection so I sit & pretend I am not.[176]

After 15 months of letting go, with "ambition and work" smothered out of her, why did Emily Carr then go to Bushey upon release from the East Anglian Sanatorium? Why not go immediately home to Canada, or to the Simmons in Addlestone, or to Scotland to the Andersons? The answer surely must be found in Carr's firm determination to heal fully through her art and her unwavering belief in art studies and its importance in her own definition of self. She had previously spent two profitable spring terms in Bushey working under John Whiteley, and connected with him as a teacher and mentor. Perhaps she saw Bushey as a place to reconnect with her art, to test herself as an artist and to see if art still formed her inner being – if so, she could build her strength. Maybe it was John Whiteley.

It has never been clear why Emily selected a brand-new TB sanatorium as the place to heal. It was away from the big city – a plus, but certainly other facilities in a country setting also offered rest and care. Yes, her family had a history of tuberculosis and she had remembrances of her brother in a sanatorium in California, and so perhaps it was a natural place to consider, as bed rest would be a focus. But reading Lizzie Carr's diary it seems as though Emily got it into her head almost overnight that this was the place. Who recommended it? My guess is that Whiteley witnessed Carr's failing health in the spring of 1902, which resulted in her abrupt departure from his school. Perhaps he wrote to her with a recommendation. He and Carr had a connection; he had steered her well in his recommendations for art masters at St Ives, and so perhaps he offered the suggestion of the East Anglian Sanatorium because he knew something about it. It was in a wonderful natural setting, in the countryside made famous by artist John Constable, but it may have been more than the setting upon which Whiteley could advise. It is probable Whiteley and Dr Jane Walker were related. Both were born in 1859 and grew up within a few miles of each other in West Yorkshire.

176 Emily Carr to Mary Cridge, 7 May 1901. City of Victoria Archives.

Emily Carr, while visiting Edna Carew-Gibson at 150 Mile House in the Cariboo, 1904.
Archibald Murchie photograph; I-51569.

Walker's sister married a Frank Whiteley. John Whiteley may have known both Walker and Frank Whiteley, and then, by extension, he would have knowledge of Walker and her sanatorium. Further research may establish a familial link. Carr's social connections in England, as revealed in this book, are characterized by their interconnectedness and close degrees, so John Whiteley as the catalyst for Carr selecting the East Anglian Sanatorium is not far fetched.

While lodging in Bushey after her release in March 1904, Emily was depressed but trying to get her life back on track. Dr Mac visited her, saw the tears, "guessed the struggle" and told Emily, "I am so proud of you" – key support that Carr took to heart as she embarked on her own therapy adjusting to life outside and waiting for Whiteley's spring classes to begin. She wrote doggerel verse and illustrated a funny book about her time at the sanatorium and mailed it off to the resident doctor, who wrote back "Bravo! How the staff roared! All the staff but matron and me, we knew its price."[177]

Carr left England in late July. Presumably her physical ailments were cured, the weak leg and headaches gone. She thought herself strong enough for the ocean voyage and cross-county train journey home after spending restorative time painting in the fields and copses alongside the village of Bushey; fresh air, sunshine and regular outdoor sketching had re-established her skills. Carr boarded the *Umbria* on July 23, 1904, and sailed from Liverpool to New York.[178] Immigration records for New York on July 30 list her among the passengers in transit. A column on the form for "occupation" notes she defined herself as an "art student." The column for "last residence" has "Herts, Eng.," confirming several months duration with Whiteley in Bushey after the sanatorium, and presumably her straight removal from Bushey to Liverpool.[179]

Emily travelled by Canadian Pacific Railway west to British Columbia and disembarked at Kamloops. She had been invited by her childhood friend Edna Green (who had married Edward Carew-Gibson while Emily was in England) to break her journey and spend a few weeks with them at their ranch near 150 Mile House. More fresh air, horseback riding – astride – and it was time to go home. On October 14, 1904, Lizzie recorded in her diary: "Millie returned from England after an eight weeks stay in Cariboo on the way. She is quite well. Oh! What a great blessing & mercy. Alice went to Vancouver to meet her."[180]

177 Carr 2005, pp. 235–36.

178 Passenger lists, National Archives, London. Indexed online at Findmypast.co.uk.

179 List of alien passengers, port of New York, July 30, 1904. Indexed online at Findmypast.co.uk. Carr did not note London, or any other place, which suggests that she remained in Bushey from her discharge in March through most of July 1904.

180 Lizzie Carr's diary, 14 October 1904. MS-2181, BC Archives.

Conclusion

On a personal level, Emily Carr grew in strength and character and took ownership over her life and her destiny while in England. Her intentions were to develop her art and to grow as an artist. And to these ends she worked hard under several masters, in several different situations, learning through repetition and experimentation, influenced by personalities and directed by opportunities. Yes, while in England her health suffered. She had a breakdown that had physical and emotional aspects; she was hospitalized and, in the process, had to walk away from her art studies. But she pulled herself back and reconnected with her inner strength of purpose. She absorbed her five-year experience and looked forward, holding on to the friendships and social connections that, in themselves, provided her with a broader outlook and memories to last a lifetime.

Emily Carr's five years in England have been underplayed in summaries of her life story – this period has remained on the fringe, glossed over or even dismissed. Carr herself had a hand in that, recalling in old age the negatives and downplaying the positives, forgetting the lessons in life and in art that became core to her very

self. In retrospect we can look back at Emily Carr's five years in England and, in the context of her times, recognize it for what it was: a serious undertaking. It took courage for a single woman to travel alone to another country; female independence was not considered a desirable trait. She saved her money earned as an art teacher to financially support this travel. Earning income as an upper-middle-class young woman was also not culturally supported. She adapted to her situation and, on her own, developed a network of connections to enable her housing, her schooling and her social activities. While she was in England, Carr was physically distant from her family and friends, from the world she knew and the people who shaped her. These people moved on themselves and, at times, away from their past shared life. Her brother died, her sisters had grave illnesses, her friends married, moved away, had children and shifted priorities. There was no standing still, no frozen-in-time life to which she could return.

In England Carr visited art galleries, talked and argued about art with her peers, attended lectures and immersed herself in new worlds of creativity and ambition. She lived and practised as a serious artist

for extended periods in art colonies. She visited and absorbed the ambiance of cultural centres and the weight of human enterprise at historical and geographical sites. These direct, first-hand and on-the-spot experiences gave her a new inclusivity. She internalized the aesthetics of art and design, of art styles and trends, the language of art and artistic endeavours, the outlook of artists and the priorities of being an artist. After these several years of art study, she now identified strongly as a legitimate artist, not as a dilettante but as an artist for whom creating and selling art took priority of time and energy.

The landscape of England, the character of its people and the weight of cultural layering also made an impact. Never again could she look at her western forests with the perspective she held prior to her stay in England. Her appreciation of British Columbia's shorelines, mountains and other natural features was now enhanced by her experiences of Tregenna Woods, Bushey's pastoral fields or Scotland's moors. She compared these tame sights to her rugged west coast and an idea surfaced, perhaps briefly, that would later flourish. At home she would no longer need to struggle, as she had in England, to visually capture a foreign landscape or to be content with the cultivated and tame. Carr now also had greater perspective with which to view people within the landscape. Bucolic farms and quaint stone buildings with cobblestone streets were not Canada, but Canada had something else to offer, something of the exotic – at least in the minds of the English. Her visits to the British Museum and other cultural institutions provided her with an understanding of how little

her country and its history were known by those overseas. Ethnological collections from British Columbia, displayed without context and viewed with little understanding of the land or peoples from where they had been plucked, registered with Carr. The stories she recounted of her brief 1899 trip to Ucluelet and sketching at the village of Hitachu had been popular with her new English friends and acquaintances. Back home, perhaps, she would have more opportunities to explore and take advantage of subject matter that interested her, and then find a niche for herself as an artist. Her visits to First Nations villages were now informed by the ethnological collections she had seen at the British Museum and by her observations of post-impressionist paintings. She returned from England somewhat chastened by the knowledge of her fragility, but strengthened by her own resolve to stay on her creative trajectory – to hold true to the intention to paint, to support herself and her artistic activities through a livelihood earned by teaching art. How she moved forward in life and art was now up to her. Little did she realize how much of a challenge that dream would be.

Emily Carr's trip to England was a coming-of-age experience. She was almost 33 when she arrived back home: no longer an impressionable young woman, no longer sheltered and protected. She had lived as a hospitalized patient for 15 long months, separated from the outside world, amid an emotional cluster of souls brought together by illness, sharing their own mortality, and shaped by the often sudden yet regular deaths in their midst. She was changed.

In later years Carr maintained that the English way of seeing was not her way

of seeing, that the art she produced in England was pedestrian, and that perhaps she had erred in choosing to study art in England, that Paris or Rome would have been a better choice. It was all hindsight. I would argue that it was the experience of England that really moved her forward. It crafted her self-identity, became a measure of how she was different, but also widened her outlook and her social connections. To have lived in England for an extended period was a mark of accomplishment, a way of legitimizing her commitment to art, and this influenced the way people thought of her. Here was a serious artist. Making friends and acquaintances in England broadened the possibilities for financial support and networking for the furtherance of her career. We know that she kept in touch with many of the people she knew in England, that correspondences and visits kept these relationships alive. She did not cut herself off but actively engaged in maintaining these connections. For instance, six years after her return, she wrote to Algernon Talmage to ask his advice about what to do with her studio (and students) while she moved to France for her own continued art studies. Mrs Redden's son and his wife visited Carr in 1924. Forty years after her return, she still exchanged letters with Mildred Crompton-Roberts, Alice Watts and Polly Anderson.

To trivialize, subordinate or omit Carr's five years in England is to dismiss her first success in achieving independence, her first great growing up and her establishment of an important network of social connections that formed the fabric of her way of seeing life. Discovering who the real people were behind the fictional names in Carr's public writing allows us to learn more about them and trace them in her later life. This enables us for the first time to understand her English years as fundamental, not inconsequential.

References Cited

Books and articles

Ashton, William. *The Life and Work of Artist Sir William Ashton*. Sydney, Australia: Legend, 1961.

Barman, Jean. *The West Beyond the West: A History of British Columbia*. Toronto: University of Toronto Press, 1991.

Beanlands, Sophia T. "Memorable Models I have Known" in *Westward Ho* magazine, 1904.

Blanchard, Paula. *The Life of Emily Carr*. Vancouver: Douglas & McIntyre, 1987.

Bridge, Kathryn. "Being Young in the Country: Settler Children and Childhood in British Columbia and Alberta, 1860–1925". PhD dissertation, University of Victoria, 2012.

Carr, Emily. *Pause, A Sketchbook*. Oxford, UK: Oxford University Press, 1951.

Carr, Emily. *Growing Pains, The Autobiography of Emily Carr*. Vancouver: Douglas & McIntyre, 2005. (Original edition published in 1946 by Oxford University Press.)

Carr, Emily. *Hundreds and Thousands, The Journals of Emily Carr*. Vancouver: Douglas & McIntyre, 2006.

Carr, Emily. "Growing Pains", unpublished manuscript, MS-2181, BC Archives, n.d. (no date).

Crean, Susan. *Opposite Contraries: The Unknown Journals of Emily Carr, and Other Writings*. Vancouver: Douglas & McIntyre, 2003.

Crozier, Gladys Beattie. "Miss Lucy Kemp Welch's School of Animal Painting at Bushey" in *The Ladies Field* magazine, April 15, 1905.

Elderkin, Susan Huntley. "Recovering the Fictions of Emily Carr". *Studies in Canadian Literature* 17:2, 1992.

Feilchenfeldt, Walter. *Vincent Van Gogh, The Years in France: Complete Paintings 1886–1890*. London, UK: Philip Wilson Publishers 2013.

Gill, Linda, ed. *Letters of Frances Hodgkins*. Auckland, NZ: Auckland University Press, 1993.

Hands, Joan, and Sandy Woodley. *Merry Hill School 1827–1972*. Kings Langley, UK: Alpine Press, 2002.

Hembroff-Schleicher, Edythe. *Emily Carr, The Untold Story*. Saanichton, BC: Hancock House, 1978.

Longman, Grant. *The Herkomer Art School (1883–1904): A Re-assessment*. Bushey, UK: Bushey Museum, 1999.

McConkey, Kenneth. *The New English: A History of the New English Art Club*. London: Royal Academy Books, 2006.

Moray, Gerta. *Unsettling Encounters: First Nations Imagery in the Art of Emily Carr.* Vancouver: UBC Press, 2006.

Morra, Linda, ed. *Corresponding Influence: Selected Letters of Emily Carr and Ira Dilworth.* Toronto: University of Toronto Press, 2006.

Setford, David. "The Herkomer School" in *Herbert Herkomer and His Students.* Watford, UK: Watford Museum, 1983.

Thom, Ian M., Charles C. Hill and Johanne Lamoureaux, eds. *Emily Carr.* Vancouver: Douglas & McIntyre, 2006.

Thomas, Hilda L. "Klee Wyck, The Eye of the Other" in *Canadian Literature* 136, 1993.

Tippett, Maria. *Emily Carr, A Biography.* Oxford, UK: Oxford University Press, 1979.

Tovey, David. "St Ives Colony" in *Oxford Dictionary of National Biography Online,* www.oxford.dnb.com, 2004.

Tovey, David. *Pioneers of St Ives Art at Home and Abroad (1889–1914).* London, UK: Philip Wilson Publishers, 2008.

Tovey, David. *St Ives (1860–1930): The Artists and the Community – A Social History.* London, UK: Philip Wilson Publishers, 2009.

Tovey, David. *The Siren. The Newsletter for those Interested in St Ives Representational Art,* issue 3, privately distributed, February 2014.

Tuele, Nicolas. "Sophia Theresa Pemberton: Her Life and Art". M.A. thesis, University of British Columbia, 1980.

Vogler, Martha S. "People Gissing Knew: Dr Jane Walker" in *The Gissing Journal* 29:2, April 1993.

Walker, Stephanie Kirkwood. *This Woman in Particular: Context for the Biographical Image of Emily Carr.* Waterloo, ON: WLU Press, 1996.

Original sources and repositories

Burgess, Arthur J.W., letters to Muriel Coldwell, Private collection.

Burns, Flora Hamilton, papers MS-2786, BC Archives.

Bushey Museum art files, Hertfordshire, UK.

Carr, Emily, papers, MS-2181, BC Archives.

Carr, Emily, papers, MS-2763, BC Archives.

Cridge family fonds, PR76, City of Victoria Archives.

East Anglian Sanatorium, Patient Register, ID507/6/1. Suffolk Record Office, Bury St Edmunds branch, London, UK.

Hembroff-Schleicher, Edythe, papers, MS-2792, BC Archives.

Newcombe family papers, MS-1077, BC Archives.

Paddon, William Locke "Mayo", 1901 diary and family communication, private collection.

Sproat, Gilbert Malcolm, noted in: jirc. ubcic.bc.ca/node.

St Ives Weekly Summary newspaper.

Westminster School of Art information file F706.2. City of Westminster Archives, London, UK.

Online access to historical sources

British Colonist newspaper, www.britishcolonist.ca.

Canada censuses, 1871–1911, viewed via indexes on Ancestry.com or FamilySearch.org.

England, Wales and Scotland censuses, 1861–1911, viewed via indexes on Ancestry.co.uk or Findmypast.co.uk.

Immigration lists, passenger lists and ship schedules from various repositories, viewed via indexes on Ancestry.co.uk or Findmypast.co.uk.

Index